Published in 2024 by Search Press Ltd.
Wellwood, North Farm Road
Tunbridge Wells
Kent TN2 3DR

This book is produced by
The Bright Press, an imprint of the Quarto Group,
1 Triptych Place, London SE1 9SH,
United Kingdom.
T (0)20 7700 6700
www.Quarto.com

ISBN: 978-1-80092-235-8
ebook ISBN: 978-1-80093-215-9

Publisher: James Evans
Editorial Director: Isheeta Mustafi
Art Director: James Lawrence
Managing Editor: Jacqui Sayers
Senior Editor: Dee Costello
Project Editor: Polly Goodman
Design: JC Lanaway

Printed and bound in China

Bookmarked Hub
For further ideas and inspiration, and to join our free
online community, visit www.bookmarkedhub.com

Faces

DRAW OVER (40) PORTRAITS IN 10 EASY STEPS

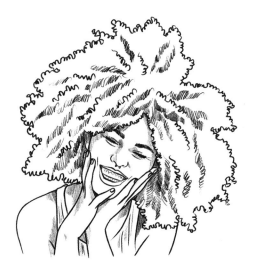

JUSTINE LECOUFFE

Search Press

Contents

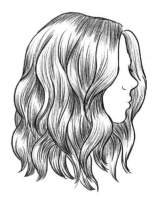

INTRODUCTION 6
HOW TO USE THIS BOOK 7

››› Key Features

Eye: Round.. 10
Eye: Almond...................................... 12
Eye: Monolid 14
Nose: Front view.............................. 16
Nose: Side view................................ 18
Mouth: Full... 20
Mouth: Thin....................................... 22
Mouth: Smiling................................. 24
Mouth: Three-quarter view............. 26
Ear: Basic.. 28
Ear: Round 29
Ear: Long ... 30
Ear: Three-quarter view 31
Hair: Textured.................................. 32
Har: Slick-back 33
Hair: Straight.................................... 34
Hair: Wavy ... 35
Neck and shoulders: Rounded 36
Neck and shoulders: Square 37

››› Face Shapes

Oval: Three-quarter view 1 40
Oval: Three-quarter view 2............ 42
Oval: Front view................................ 44
Rectangle: Front view...................... 46
Rectangle: Three-quarter view 1 ... 48
Rectangle: Three-quarter view 2 ... 50
Round: Three-quarter view 52
Square: Three-quarter view 54
Square: Front view 1 56
Square: Front view 2 58
Diamond: Three-quarter view 1 60
Diamond: Three-quarter view 2 62
Diamond: Front view....................... 64
Heart: Front view 1 66
Heart: Front view 2 68
Heart: Three-quarter view.............. 70

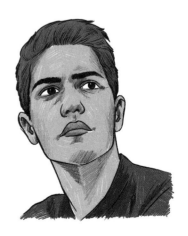

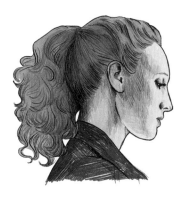
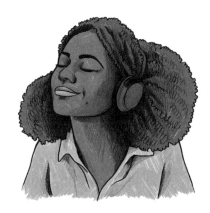

>>> Expressions and Poses

Chin up .. 74

Strike a pose .. 76

Looking askance 78

Peace out! .. 80

Wisdom .. 82

Downcast .. 84

Contemplative 86

Joyful .. 88

The singer .. 90

Statement hair 92

The chuckle .. 94

Collar up .. 96

Looking back .. 98

Angular style 100

Power of music 102

Thinking .. 104

The smile .. 106

>>> Children

Ready to play 110

Eager to learn 112

Party crown .. 114

Woolly hat .. 116

Baby laugh .. 118

Surprise! .. 120

Baby bonnet 122

Curiosity .. 124

Superhero .. 126

ABOUT THE ARTIST **128**

ACKNOWLEDGEMENTS **128**

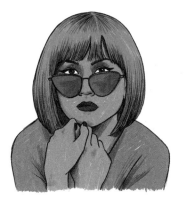
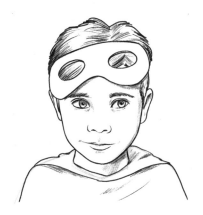

Introduction

In this book, you will find 42 illustrations of different faces that have been created in just 10 simple steps. Whether it's a baby's laugh, a cool and steely stare, or a pensive gaze, it's time to choose your favourite face and get drawing.

Drawing faces is easier than you may think because they share the same basic features. This book breaks down those features into simple shapes, to help you master them before you use them in a full head-and-shoulders portrait.

TACKLING DIFFERENT SHAPES

Each drawing in this book begins with one or two simple shapes. The step-by-step instructions then advise you to use further shapes and guidelines to help place the facial and other features. This will enable you to get the proportions of your portrait right. Following the instructions on which shape each element should be will help you achieve the overall appearance of different faces and expressions.

COLOURS

I have also provided a colour palette at the end of each finished drawing. Use this as a guide for the different skin tones, but feel free to experiment and use your favourite shades for the hair, make-up and clothing.

I hope you will enjoy creating the faces in this book as much as I did. Drawing has never been easier!

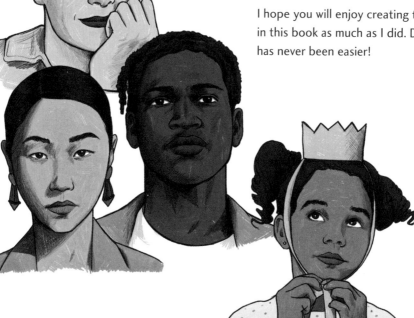

How to use this book

BASIC EQUIPMENT

Paper: Any paper will do, but sketch paper will give you the best results.

Pencil, eraser and pencil sharpener: Try different pencil grades, and invest in a good-quality eraser and sharpener.

Pen: For inking the final image. A medium or fine ink pen is best (ink is better than ballpoint because it dries quickly and is less likely to smudge).

Small ruler: This is optional, but you may find it useful for drawing guidelines.

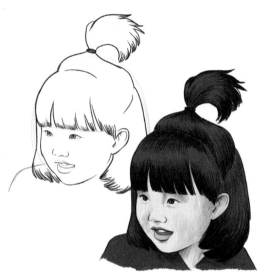

BLUE, PURPLE AND BLACK LINES

Blue: For your guide shapes. They represent the basic shapes and wireframes of the illustrations.

Purple: For guidelines within the shapes. They help to position the eyes, nose and other facial features.

When drawing your own guide shapes and guidelines use a pencil, so you can rub them out when you're ready.

Black: For the final image. These lines are intended to be part of the final illustration and can be drawn in ink. However, if you're not confident, you can keep these in pencil so you can correct them, and then just trace over the final shapes when you have perfected your drawing. Remember to let the ink dry before rubbing out the underlying pencil

COLOURING

You have several options when it comes to colouring your drawings – why not explore them all?

Pencils: This is the simplest option. A good set of coloured pencils with about 24 shades is really all you need.

Stay inside the lines and keep your pencils sharp so you have control in the smaller areas.

To achieve a lighter or darker shade, try layering the colour or pressing harder with your pencil.

Paint and paintbrushes: Watercolour is probably easiest to work with for beginners, although using acrylic or oil means that you can paint over any mistakes. You'll need two or three brushes of different sizes, with at least one very fine brush.

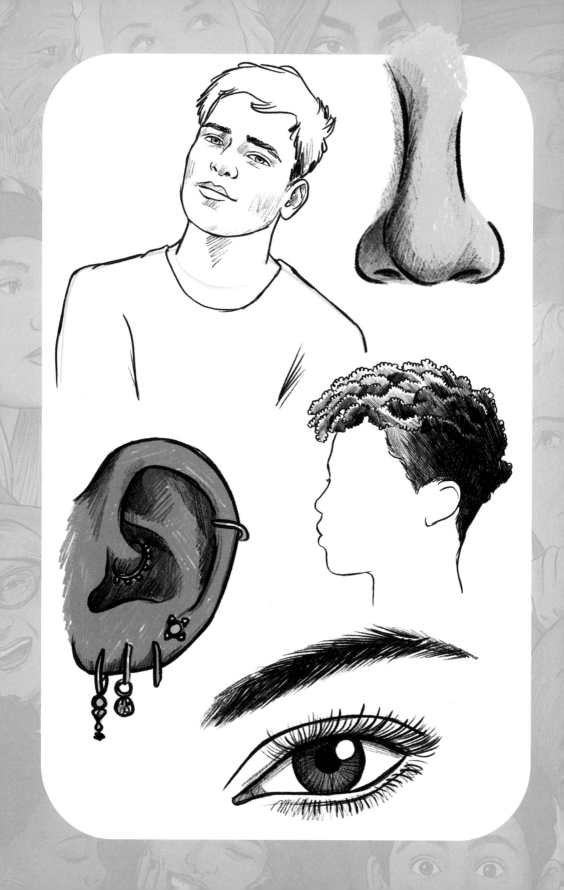

Key Features

Eye

Round

Start with this round-shaped eye. The more
shading you add, the rounder the eye will look.

1 Draw a circle as a guide for the iris.
Add a horizontal line through the
lower part of the circle.

2 Create arcs that meet each other on
the guideline. The upper arc should
overlap the top of the iris circle.

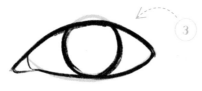

3 Ink over the guidelines. Add a small,
rounded, triangular shape to one side for the
inner corner of the eye. Erase your guidelines.

4 Add a circular highlight to show light
reflection, then draw the pupil just to the side.
Ensure the pupil is in the centre of the circle.
Fill in the pupil with a black pen.

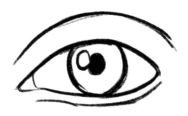

5 Sketch a curved line above, and another
one below the eye to illustrate the creases.
Make sure the top curve is quite far up to
make the whole eye shape circular.

10

6 Add eyelashes along the eyelids, leaving the inner corner of the eye free. Relax your hand and make short, swift movements. Some eyelashes can be slightly longer than the others, to help make them look realistic.

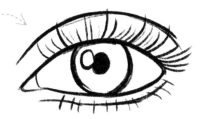

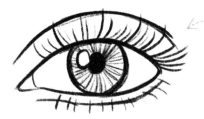

7 Use short, straight lines radiating from the pupil to the edge of the iris.

8 Shade around the outer edge of the iris. Add some shading along the upper eyelid, over and under it, to show the shadow it casts. Add some shading to the bottom eyelid, too.

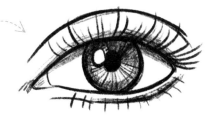

9 Add shading above the upper crease, and more creases under the eye. Colour the iris. Create a pencil guideline for the eyebrow.

10 Draw the eyebrow along the guideline using a series of strokes. Change the direction of the strokes after the bend. Finish by adding some shading between the eyebrow and the eye, to reinforce the depth of the eye socket.

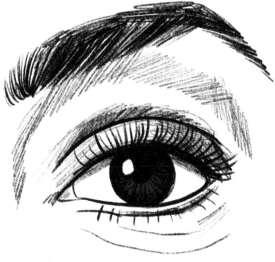

Eye
Almond

Use shallow curves for an almond-shaped eye,
with a teardrop shape for the inner corner.

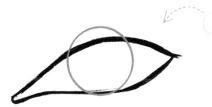

1 Draw a circle for the iris. Ink an almond-shaped outline for the eyelids. Make the inner corner of the eye lower and shallower than the outer corner. The upper eyelid should overlap the top of the circle guide.

2 Ink around the iris guidelines, keeping within the eye. Erase the guideline.

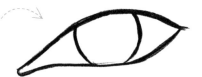

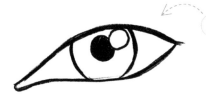

3 Create a circular highlight, then add the pupil to the side and under it. Ensure the pupil is in the centre of the iris. Fill in the pupil with a black pen.

4 Add the crease of the upper eyelid, then the lower eyelid.

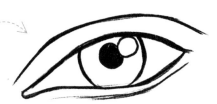

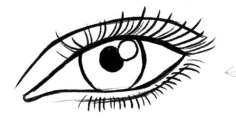

5 Create eyelashes along the eyelids using short, curved strokes. Trace some shorter, some longer, some thinner, some thicker, to make them realistic. Leave the inner corner of the eye free of lashes.

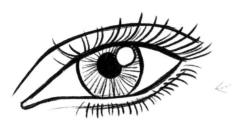

6 Sketch some lines from the pupil to the edge of the iris.

7 Add some shading around the edge and top of the iris. This will add depth and roundness.

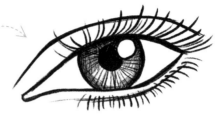

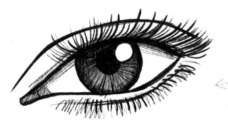

8 Shade just under the upper eyelid, behind both top and bottom lashes, and the inner corner of the eye. Colour the iris.

9 Draw a pencil guide for the eyebrow. Follow the almond shape of the eye, and draw a line that goes upwards, and then bends down towards the outer edge of the eye.

13

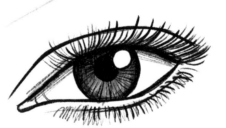

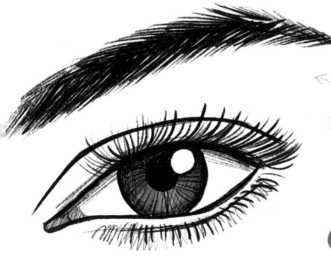

10 Add the eyebrow along the guideline using a series of strokes. Use shorter strokes towards the outer part of the eyebrow.

Eye
Monolid

Now you've mastered the round and the
almond-shaped, try this monolid eye.

1) Draw a circle for the iris. Ink two curved
lines for the basic eye shape. The upper
curve should overlap the top of the circle
guide. Add a short curve to one side for
the inner corner of the eye.

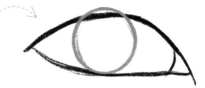

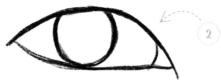

2) Ink around the iris guideline,
keeping within the eye. Erase
the guideline.

3) Create a circular highlight, then draw
the pupil beneath. Ensure the pupil is
in the centre of the iris. Fill in the
pupil with a dark pen.

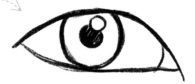

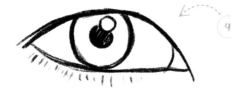

4) Start adding some small strokes
on the lower eyelid to create the
bottom eyelashes.

5) Sketch some lines from the
pupil to the edge of the iris.

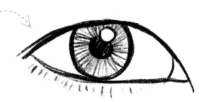

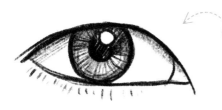

6 Shade along the top part of the eye, just under the line for the upper eyelid, but not above it.

7 Add some shading below the bottom eyelid as well. The more shading you add, the more bulgy the eye will look.

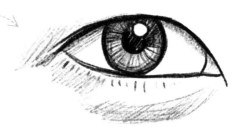

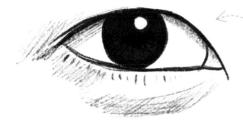

8 Colour the iris.

9 Trace a pencil guideline for the eyebrow, above the eye.

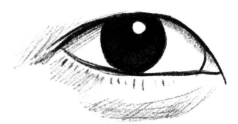

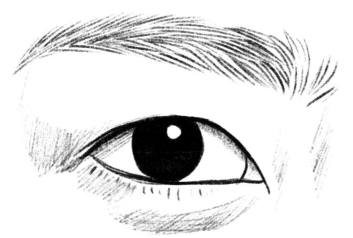

10 Sketch the eyebrow along the guideline using a series of strokes.

Nose
Front view

Let's start with a nose from the front. Noses are best drawn using shading instead of hard lines because they have few distinct edges.

1 Draw a circle.

2 Balance two curved, vertical lines above the circle.

3 Add the nostrils by drawing two smaller circles on the sides of the first circle.

4 Start to ink parts of the outline. Choose which parts to outline and which to leave.

5 Use shading to add the nostril openings. Add the curved shapes around them. Erase your guidelines.

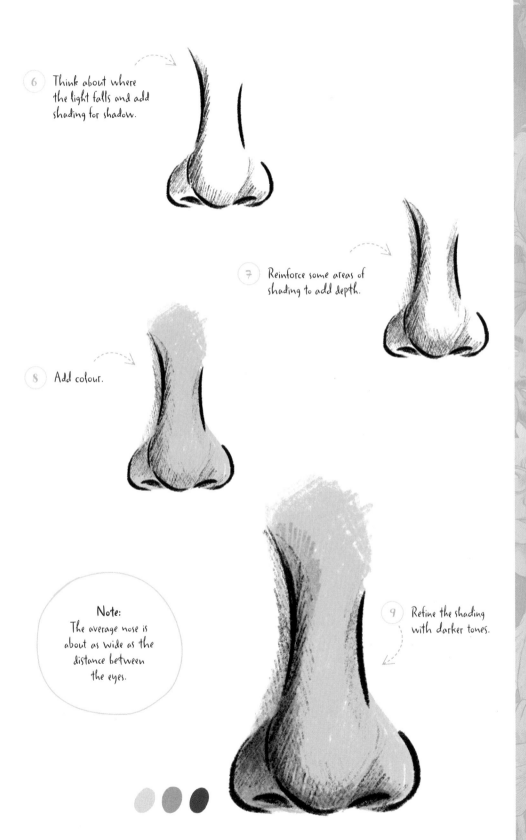

6 Think about where the light falls and add shading for shadow.

7 Reinforce some areas of shading to add depth.

8 Add colour.

9 Refine the shading with darker tones.

Note:
The average nose is about as wide as the distance between the eyes.

Nose
Side view

Noses come in different shapes and sizes, and the shape is most clearly seen in side profile. This nose is slightly concave.

1 Draw two circles as shown here. The larger one will become the tip of the nose and the smaller one the bulbous part around the nostril.

2 Add a vertical, dashed guideline to the side of the smaller circle, for the bridge of the nose.

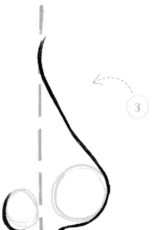

3 Ink a curved line up and around the larger circle to form the base, tip and bridge of the nose. To the left of the smaller circle, draw a short curve to show the fold.

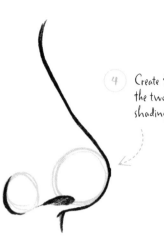

4 Create the nostril between the two circles using a little shading. Erase your guidelines.

5 Erase the guidelines. Notice where the light falls and add shading for shadow.

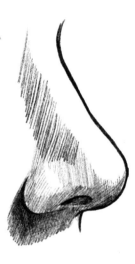

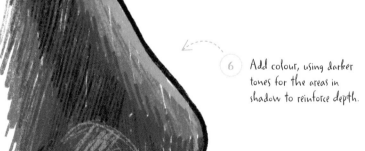

6 Add colour, using darker tones for the areas in shadow to reinforce depth.

Mouth
Full

Every mouth is different, but like noses, the key is in
the shading and tone. Start with these full lips.

(1) Draw a horizontal line.
Create two arcs that meet
at each end of the line.

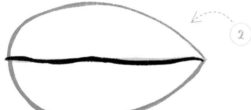

(2) Ink a slightly curvy line
along the horizontal guide.

(3) Create the outline of the upper lip,
adding a little dip in the middle.
Erase the upper guideline.

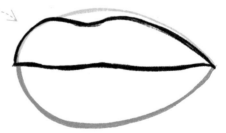

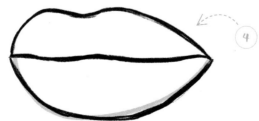

(4) Trace the outline of the lower
lip. Generally, the lower lip is a
little fatter than the upper lip.
Erase the lower guideline.

5 Lips have fine, vertical creases in them. Make a series of curves across the top and bottom of the lower lip. Repeat on the top lip, but only along the bottom edge since they're less noticeable there.

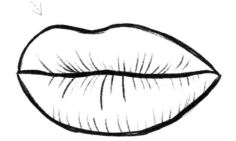

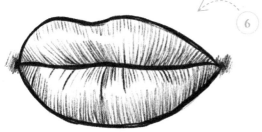

6 Add shading, depending on where the light falls. The brightest areas will be the parts that protrude the most, including the middle of the lower and the top of the upper lip. Leave these areas white. Add a little shading at each corner of the mouth to anchor it to your drawing.

Note:
Keep a little sketchbook to practise different lip shapes.

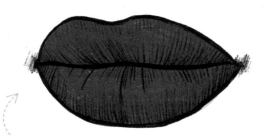

7 Fill with colour.

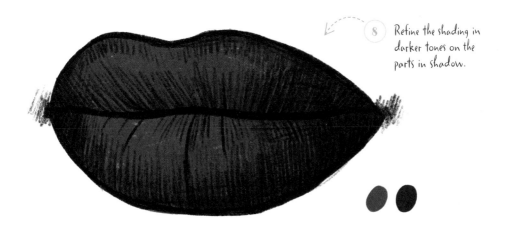

8 Refine the shading in darker tones on the parts in shadow.

Mouth
Thin

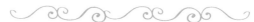

Now you've mastered full lips, try this thinner, wider pair.
Think about where the light falls to help position shading for shadow.

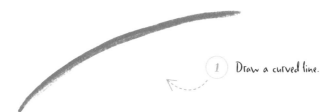

(1) Draw a curved line.

(2) Add guidelines for the
upper and lower lips.

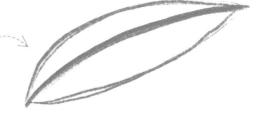

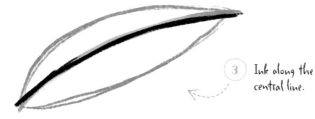

(3) Ink along the
central line.

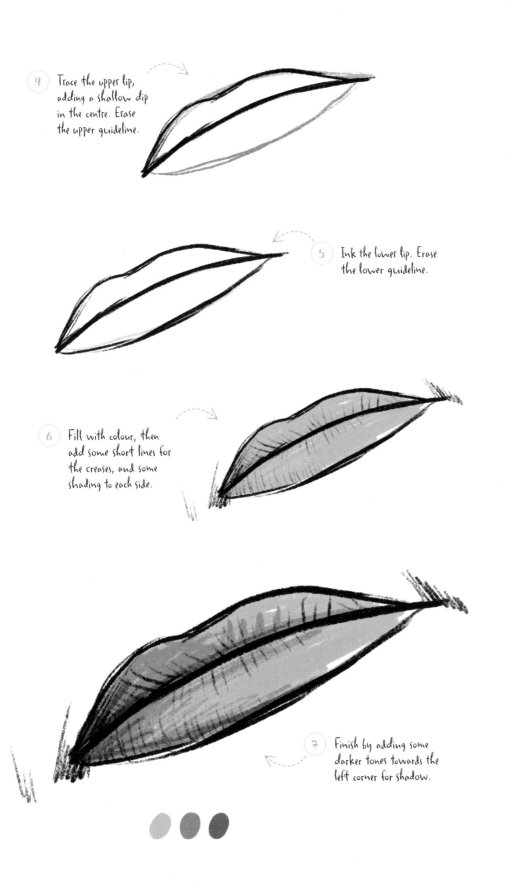

4 Trace the upper lip,
 adding a shallow dip
 in the centre. Erase
 the upper guideline.

5 Ink the lower lip. Erase
 the lower guideline.

6 Fill with colour, then
 add some short lines for
 the creases, and some
 shading to each side.

7 Finish by adding some
 darker tones towards the
 left corner for shadow.

Mouth
Smiling

Contrasting tones and shadows give this mouth a dazzling smile!
Think about perspective throughout this drawing.

1 Draw a loose, horizontal line, with a curved line below. This will be the mouth opening.

2 Ink the curvy outline of the upper lip. Erase the upper guideline.

3 Now ink the lower lip. Erase the lower guideline.

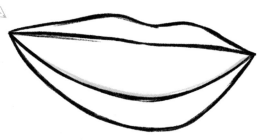

4 Sketch the top and bottom teeth across the length of the mouth. Keep the lines faint to prevent the teeth standing out too much.

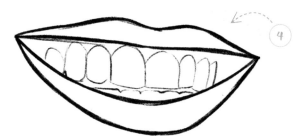

5 Add short creaselines to both lips. Then add shading to the gums and between the teeth.

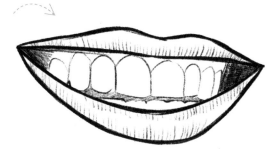

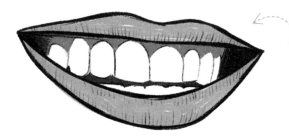

6 Colour the lips and gums.

Note:
When blending, it's easier to go from dark to light. Fade into the light gradually by lightening your touch.

7 Think about where the light falls and add more shading in darker tones. Use a darker tone to colour the inside of the mouth, keeping the teeth white.

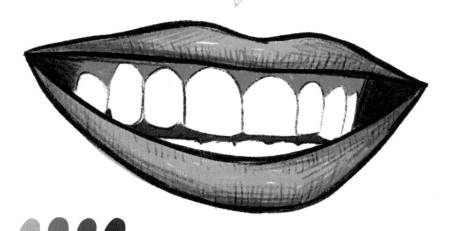

Three-quarter view

A few simple, curved lines and some well-placed shading make this three-quarter view of a mouth easy to create.

1 Draw a triangle. Add a line through the centre to make two triangles.

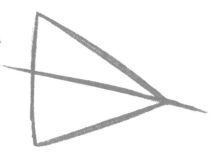

2 Ink the top lip with a curved line in the upper triangle, like the one shown here. The line can roughly follow the outline of the triangle. Erase the upper triangle guideline.

3 Continue with the bottom lip, as shown here. The space between the top and bottom lips will create the teeth. Erase the remaining guidelines.

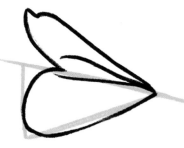

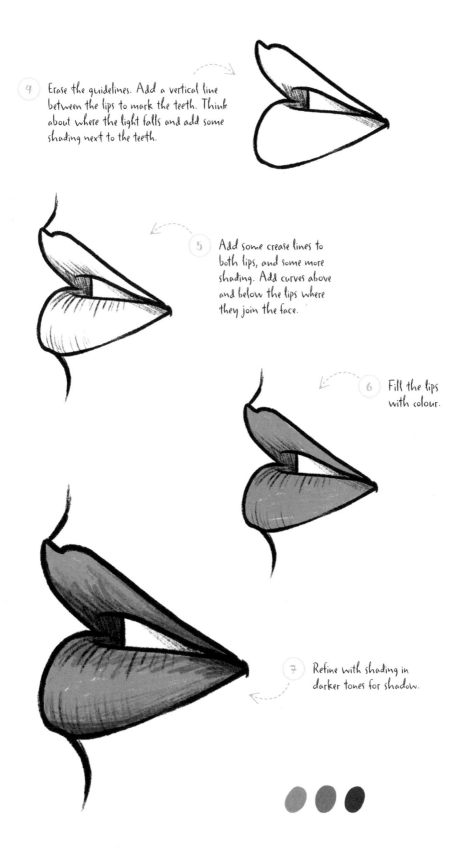

4 Erase the guidelines. Add a vertical line between the lips to mark the teeth. Think about where the light falls and add some shading next to the teeth.

5 Add some crease lines to both lips, and some more shading. Add curves above and below the lips where they join the face.

6 Fill the lips with colour.

7 Refine with shading in darker tones for shadow.

Ear
Basic

Try this basic ear shape first, using a simple egg shape, curvy lines and shading.

1. Draw an egg-shaped guideline.

2. Ink around the guideline, as shown here, for the edge of the ear.

3. Erase the guideline. Add curved lines inside the ear to show the bumps and folds, as shown here.

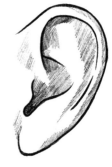

4. Think about where the light falls and add shading for shadow. Shade the deepest parts of the ear the darkest.

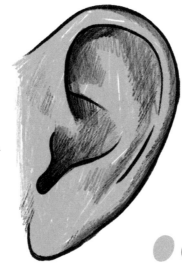

5. Add colour, with more shading in darker tones.

Ear
Round

Round-shaped ears with fleshy lobes are ideal for piercings.
Add your favourite styles of earrings.

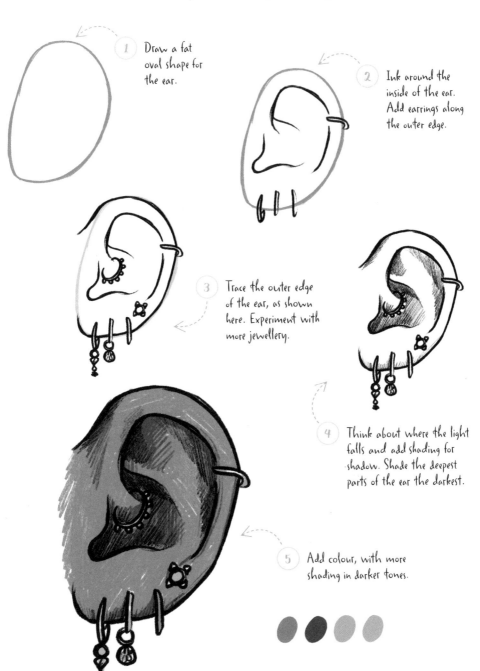

1 Draw a fat oval shape for the ear.

2 Ink around the inside of the ear. Add earrings along the outer edge.

3 Trace the outer edge of the ear, as shown here. Experiment with more jewellery.

4 Think about where the light falls and add shading for shadow. Shade the deepest parts of the ear the darkest.

5 Add colour, with more shading in darker tones.

Ear
Long

Long ears look good with a simple, solid flash of colour in the form of a single earring.

(1) Draw an egg-shaped guideline, angled to one side.

(2) Ink around the guideline for the edge of the ear, as shown here. Add a square shape at the bottom for the earring.

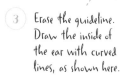

(3) Erase the guideline. Draw the inside of the ear with curved lines, as shown here.

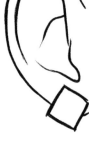

(4) Think about where the light falls and add shading for shadow. Shade the deepest parts of the ear darker and the bumps lighter.

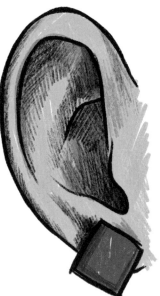

(5) Add colour, with darker tones over the shaded areas. Add some bright colour to the earring.

Ear
Three—quarter view

This view of the ear is the most common when drawing people.
Perspective is important when drawing from this angle.

1. Draw a long, oval shape.

2. Ink around the guideline for the edge of the ear. Add a curve, as shown here.

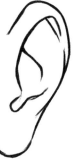

3. Erase the guideline. Draw the inside of the ear with curved lines.

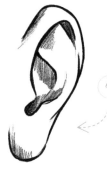

4. Think about where the light falls and add shading for shadow. Shade the deepest parts of the ear darker and the bumps lighter.

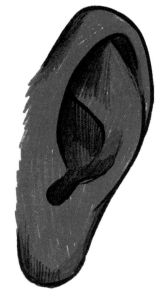

5. Add colour, with darker tones over the shaded areas for more depth.

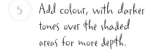

Hair
Textured

Loose rows of tiny curls give textured hair its depth.
It contrasts well with the clipped hair below.

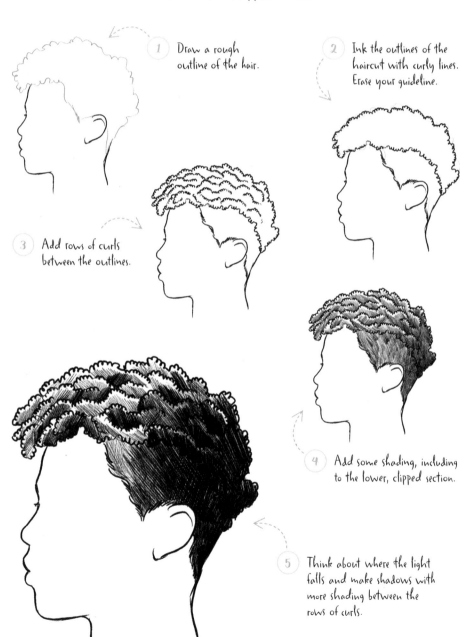

1. Draw a rough outline of the hair.

2. Ink the outlines of the haircut with curly lines. Erase your guideline.

3. Add rows of curls between the outlines.

4. Add some shading, including to the lower, clipped section.

5. Think about where the light falls and make shadows with more shading between the rows of curls.

Hair
Slick-back

This slick-back style uses all the strokes – short, long, straight and wavy.
Think about the direction of hair growth as you draw.

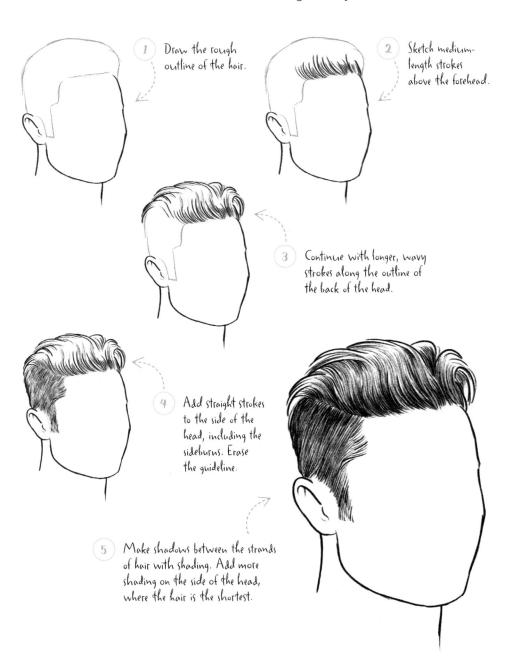

1 Draw the rough outline of the hair.

2 Sketch medium-length strokes above the forehead.

3 Continue with longer, wavy strokes along the outline of the back of the head.

4 Add straight strokes to the side of the head, including the sideburns. Erase the guideline.

5 Make shadows between the strands of hair with shading. Add more shading on the side of the head, where the hair is the shortest.

33

Hair
Straight

Sleek, straight hair is easy to draw, but make sure you don't make your lines too straight for a more natural look.

1. Draw the outline of the hair.

2. Ink the outline of the hair, adding some short strokes either side of the parting and at the ends.

3. Erase the guidelines and add more strokes to the parting, the ends, and around the neck area.

4. Think about where the light falls and add long strokes in between. Make sure the lines are not perfectly straight, to keep a natural look.

5. Add more shading to make the drawing more 3D.

Hair
Wavy

Long, thin strands between thicker waves
create a hairstyle full of volume.

1. Draw the outline
of the hair.

2. Ink a wavy outline
surrounding the face.

3. Add more waves of
hair. Divide each strand
into small strands at
the tips.

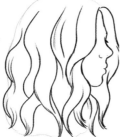

4. Add shorter waves
between the larger strands,
then trace the top outline.
Erase your guidelines.

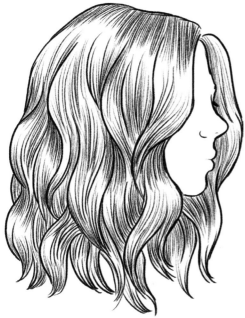

5. Think about where the light
falls and add shading between
the waves.

Neck and shoulders
Rounded

Shoulders are easy if you draw the general shape before you begin. Start with these rounded shoulders.

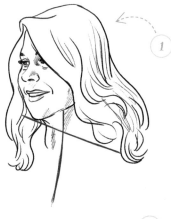

1. Look at the posture of your subject and how the neck is aligned with the torso. Draw a cross to mark the angle of the shoulders in relation to the neck.

2. Use the cross to sketch the rough shape of the shoulders.

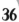

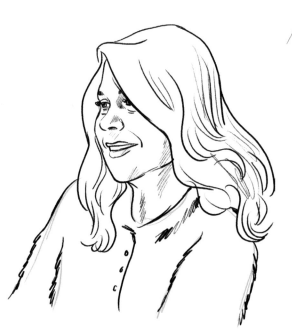

3. Ink over the guidelines with loose strokes, adding detail for the neckline and buttons.

Neck and shoulders
Square

The head and neck stand more proudly
from square shoulders.

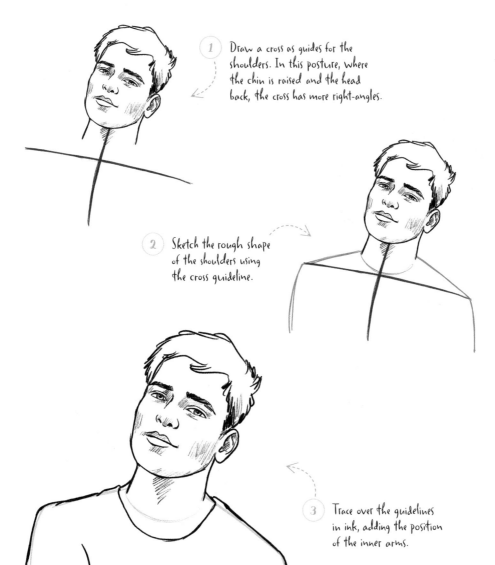

1. Draw a cross as guides for the shoulders. In this posture, where the chin is raised and the head back, the cross has more right-angles.

2. Sketch the rough shape of the shoulders using the cross guideline.

3. Trace over the guidelines in ink, adding the position of the inner arms.

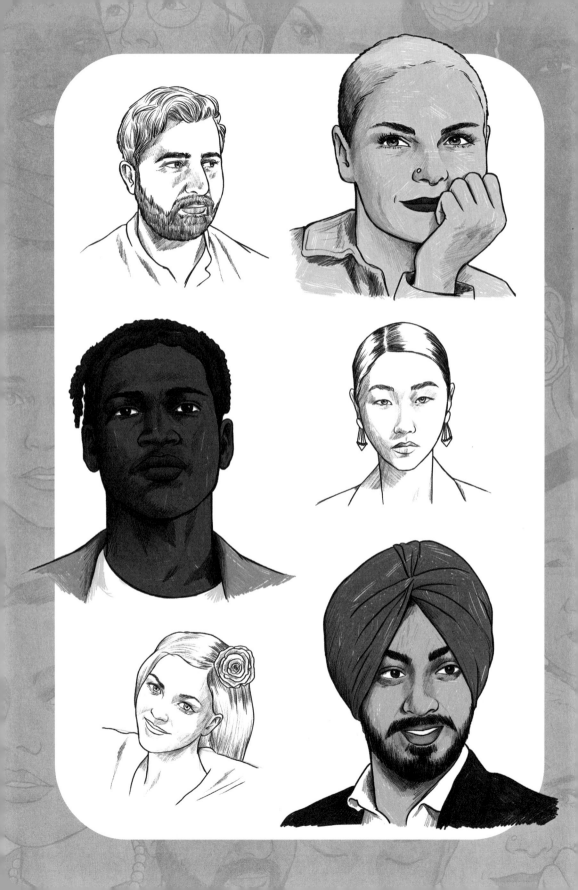

Face

Shapes

Oval
Three-quarter view 1

Let's start with the easiest face shape to draw – the oval.
A typical oval face has a round jawline and chin.

1 Draw an oval. Add two dashed lines across the centre.

2 Add a smaller oval on the left, between the dashed lines, for the ear. Trace an arc over the head as a guide for the hair.

3 Sketch a rough guide for the hand, neck and shoulders.

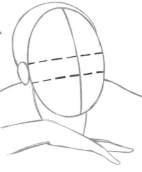

4 Ink the eyes and eyebrows along the upper dashed line.

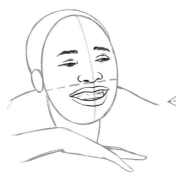

5 Continue with the mouth and nose, using the guidelines to help position them.

6 Start to outline the face and ear.

7 Add tiny curls along the guidelines with wiggly lines.

Note:
Position the top of the eyebrow and bottom of the nose so that they're lined up with the height of the ear. This helps the face look more natural.

8 Ink the shoulders and hands, then erase the guidelines. Think about where the light falls and add shading.

9 Start colouring in.

41

10 Finish with more shading in darker tones.

Oval
Three-quarter view 2

The strength of the light source and angle of the face
can have a big impact on portrait drawing.

1. Draw an oval. Add two
dashed, horizontal lines
across the centre.

2. Add a small oval on the right
for the ear, between the two
dashed lines. Draw the outline
of the hair over the top.

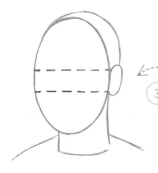

3. Sketch the neck
and shoulders.

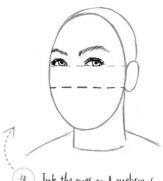

4. Ink the eyes and eyebrows
along the upper dashed line.

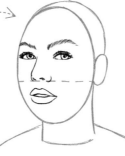

5. Continue with the
mouth and nose.
Erase your guidelines
as you progress.

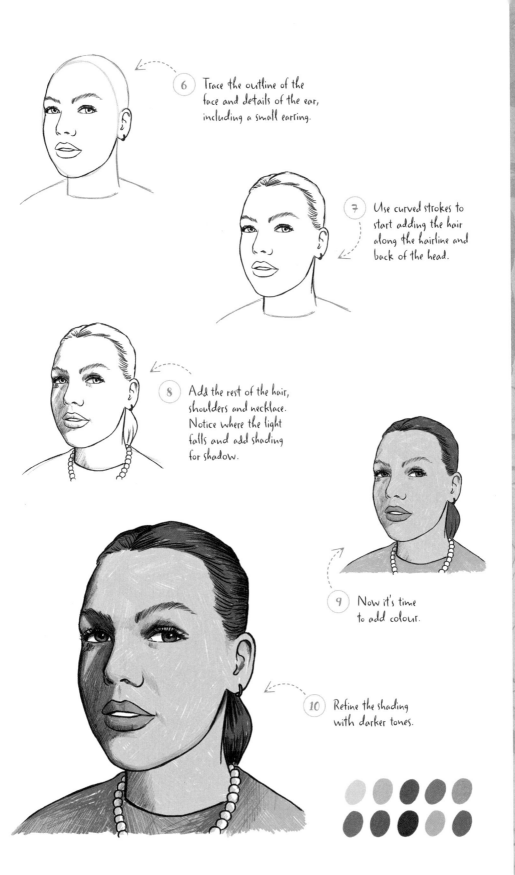

6 Trace the outline of the face and details of the ear, including a small earring.

7 Use curved strokes to start adding the hair along the hairline and back of the head.

8 Add the rest of the hair, shoulders and necklace. Notice where the light falls and add shading for shadow.

9 Now it's time to add colour.

10 Refine the shading with darker tones.

Oval
Front view

A turban can accentuate the shape of a face,
as can different styles of facial hair.

1 Draw an oval. Add two dashed, horizontal lines across the centre.

2 Create an arc with a V-shape in the centre for the turban. Erase the guidelines within the turban's outline.

3 Sketch the neck and shoulders.

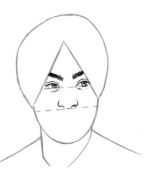

4 Ink the eyes, eyebrows and nose, using the dashed lines for positioning. Erase your guidelines as you progress.

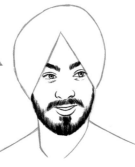

5 Continue with the mouth and beard, using short strokes.

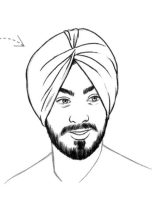

6 Add fold lines to the turban.

7 Continue with folds for the shirt and jacket.

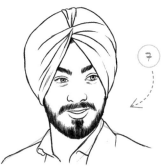

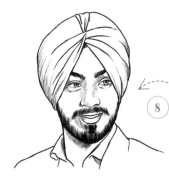

8 Think about where the light falls and add shading for shadow.

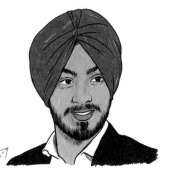

9 Colour your portrait.

10 Complete your drawing with more shading in darker tones.

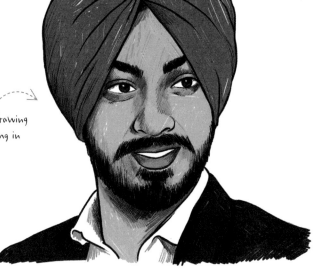

Rectangle
Front view

The forehead and jawline of a rectangular face is approximately the same width. Try different styles of beards to see how they frame the face.

1. Draw an oval for the face and chin. Add a rectangle within it.

2. Add a horizontal, dashed line through the centre of the oval. Sketch the neck and shoulders.

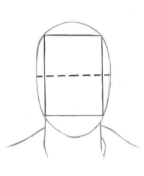

3. Continue with a vertical line through the centre, and a second horizontal, dashed line through the lower half of the rectangle. Add small ovals for the ears.

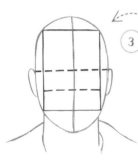

4. Ink the eyes and eyebrows along the upper dashed line.

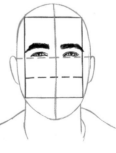

5. Continue with the nose and mouth, using the guidelines to position them. Erase the guidelines as you progress.

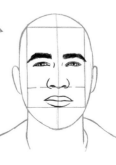

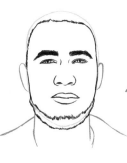

6 Trace along the hairline and outline of the beard with a series of short strokes.

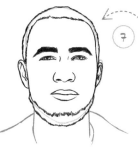

7 Complete the top of the head, and add detail to the ears.

Note:
Observe how the light falls on your subject and use it to make the curves and contours pop.

8 Notice where the light falls and add shading for shadow.

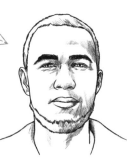

9 Colour the skin, hair and clothing.

10 Refine the colour with darker shades.

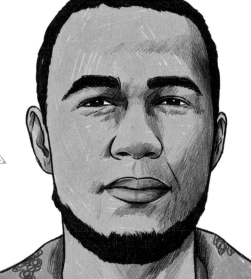

Rectangle
Three-quarter view 1

Try this three-quarter view of a rectangular face, using a rectangular guide shape to get the proportions and perspective right.

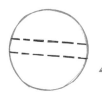

1 Draw a circle. Add two dashed, horizontal lines across the centre, angled down slightly from left to right.

2 Add a rectangle to the left of the circle, as below.

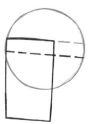

3 Create the outline of the jaw around the rectangle and connect to the circle on the right. Add a small oval for the ear.

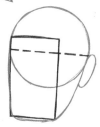

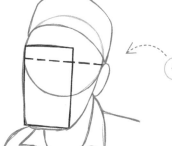

4 Sketch the hat, shoulders and shirt collar.

5 Ink the eyes and eyebrows along the dashed line. Continue with the nose and mouth. Erase the guidelines as you progress.

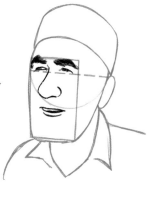

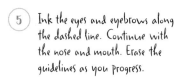

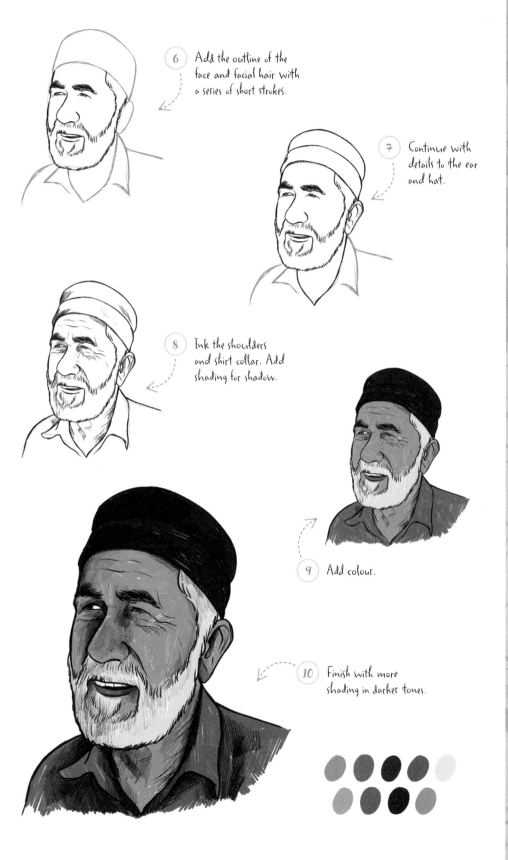

6 Add the outline of the face and facial hair with a series of short strokes.

7 Continue with details to the ear and hat.

8 Ink the shoulders and shirt collar. Add shading for shadow.

9 Add colour.

10 Finish with more shading in darker tones.

49

Rectangle
Three-quarter view 2

Older features are fascinating to draw. A hat, glasses
and other accessories add the finishing touches.

① Draw a circle. Add a
dashed line across the top
half, angled up slightly
from left to right. Add a
rectangle to the bottom left.

② Create the outline of the jaw
around the rectangle and connect to
the circle on the right. Add a small
oval for the ear. Trace the shape of
the hat over the face circle.

③ Add a vertical line to the
bottom of the jaw. Outline
the neck, shoulders, clothes
and necklace.

④ Ink the glasses and eyes
within the rectangle.
Notice the tiny lines at
the sides of the eyes.

⑤ Continue with the eyebrows,
nose and mouth. Erase your
guidelines as you progress.

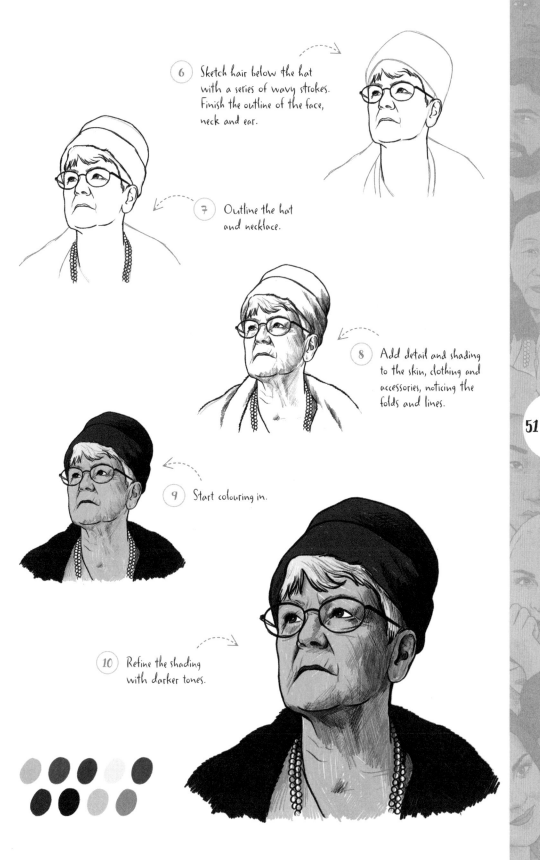

6 Sketch hair below the hat with a series of wavy strokes. Finish the outline of the face, neck and ear.

7 Outline the hat and necklace.

8 Add detail and shading to the skin, clothing and accessories, noticing the folds and lines.

9 Start colouring in.

10 Refine the shading with darker tones.

Three-quarter view

Practise drawing this thick beard and hair with
a variety of strokes to capture the texture.

1 Draw a circle. Add
a U-shape below for
the jaw.

2 Add a second circle (shown in purple)
below and right of the first one.
Draw the outline of the hair above,
and a small oval on the left for the
ear. Erase the first (blue) circle guide.

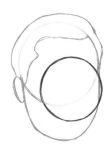

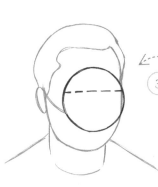

3 Sketch the neck and
shoulders. Add a
horizontal, dashed
line across the circle.

4 Start to ink the eyes
and eyebrows along
the dashed line.

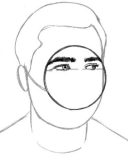

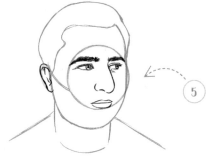

5 Continue with the nose,
mouth and ear. Erase the
guidelines as you progress.

6 Add the outline of the face and facial hair with a series of short strokes.

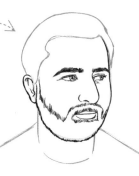

7 Draw the outline of the hair with looser strokes. Add detail to the shirt.

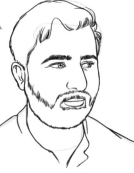

8 Fill in the hair and beard with a variety of strokes. Add shading for shadow.

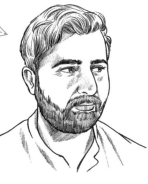

9 Start to add colour to the skin, eyes, hair and clothing.

10 Add darker tones to the areas in shadow to finish.

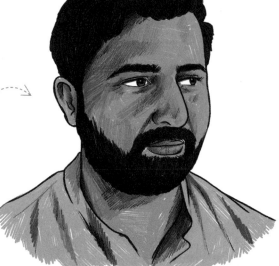

Three-quarter view

A simple, chic hairstyle indicates individuality and strength,
where a hand to cheek suggests shyness.

1 Draw an oval. Add a square within the oval.

2 Divide the square in half with a horizontal, dashed line. Add an arc above as a guideline for the hair and a small, oval shape for the ear.

3 Sketch a rough guide for the hand, neck and shoulders.

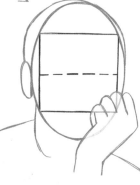

54

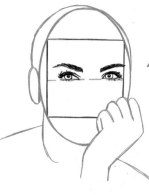

4 Start to ink the eyes and eyebrows along the dashed line.

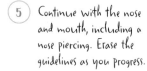

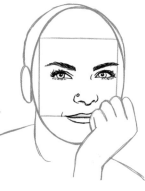

5 Continue with the nose and mouth, including a nose piercing. Erase the guidelines as you progress.

6 Create the outline of the hand.

7 Draw the hair along the guidelines with a series of short strokes. Add the outline of the face, and detail to the ear.

8 Add the neck, shirt collar and sleeve. Notice where the light falls and add shading for shadow.

9 Fill with colour.

10 Finish with more shading in darker tones.

Square
Front view 1

This square face drawn from the front
is full of strength and attitude.

1. Draw an oval. Add
 a square within it.

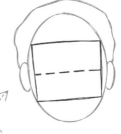

2. Divide the square in half with a
 horizontal, dashed line. Add an
 arc above as a guideline for the
 hair and a small, oval shape on
 each side for the ears.

3. Sketch the neck
 and shoulders.

4. Start to ink the eyes
 and eyebrows along
 the top of the square.
 Ink the nose along the
 dashed centre line.

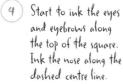

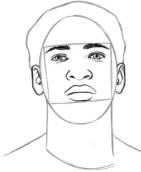

5. Continue with the mouth
 and ears. Erase the guidelines
 as you progress.

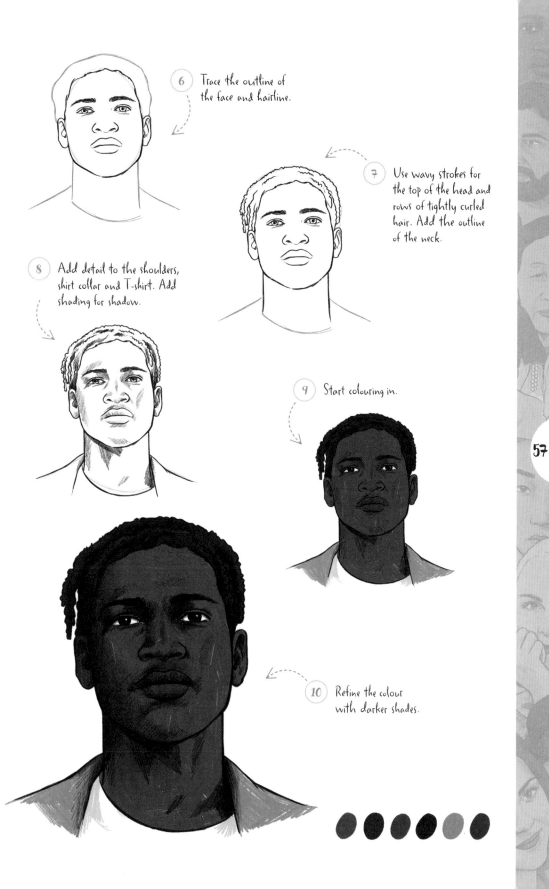

6. Trace the outline of the face and hairline.

7. Use wavy strokes for the top of the head and rows of tightly curled hair. Add the outline of the neck.

8. Add detail to the shoulders, shirt collar and T-shirt. Add shading for shadow.

9. Start colouring in.

10. Refine the colour with darker shades.

57

Front view 2

Older and wiser, use fine strokes to indicate
the skin of an older subject.

1 Draw an oval. Add
 a square within it.

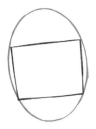

2 Divide the square with two
 horizontal, dashed lines.
 Add vertical line through
 the centre of the oval.

58

3 Create the outline of the
 hair, with a flower to one
 side. Add a small, oval
 shape on each side for the
 ears. Outline the neck
 and shoulders.

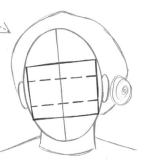

4 Begin to ink the eyes and
 eyebrows along the top of
 the square and upper
 dashed guideline.

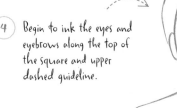

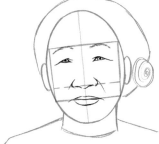

5 Continue with the nose
 and mouth. Erase the
 guidelines as you progress.

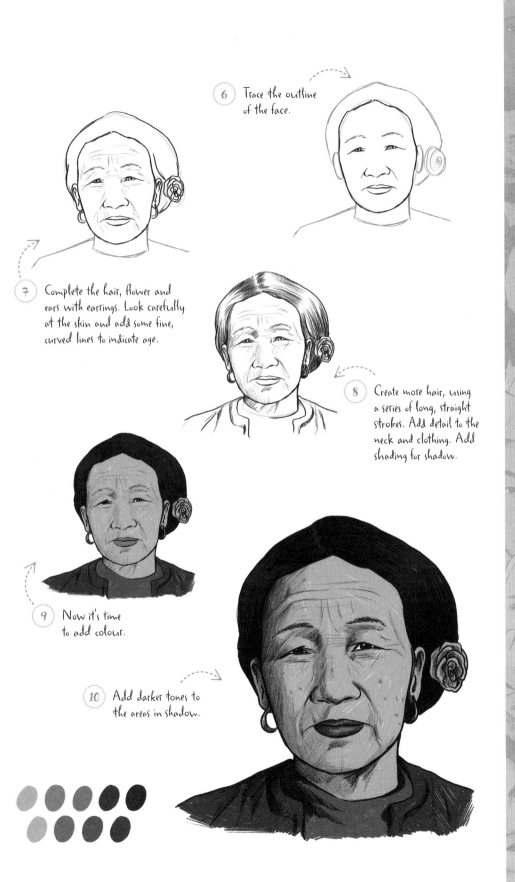

6 Trace the outline of the face.

7 Complete the hair, flower and ears with earrings. Look carefully at the skin and add some fine, curved lines to indicate age.

8 Create more hair, using a series of long, straight strokes. Add detail to the neck and clothing. Add shading for shadow.

9 Now it's time to add colour.

10 Add darker tones to the areas in shadow.

Diamond
Three-quarter view 1

Diamond-shaped faces have a pointed chin,
with a narrow jawline and forehead.

1. Draw a circle for the face. Add a straight line across the centre, and a rounded V-shape below for the jaw.

2. Sketch the outline of the neck and shoulders. Within the head shape, draw a diamond shape.

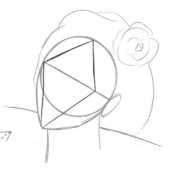

3. Create the outline of the hair, adding a flower shape. Add an oval to one side of the head for the ear.

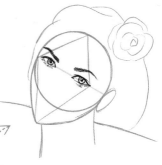

4. Start drawing the eyes and eyebrows along the straight line. See how the outer corners of the eyes meet the corners of the diamond shape.

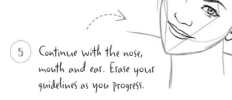

5. Continue with the nose, mouth and ear. Erase your guidelines as you progress.

6. Ink the outline of the face and hair.

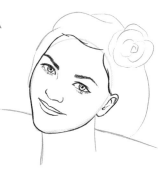

7. Continue to ink the hair and add details to the rose.

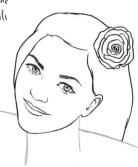

8. Outline the neck and shoulders. Notice where the light falls and add shading for shadow.

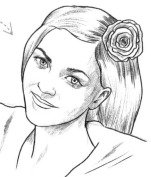

9. Colour the skin, eyes, hair and clothing. Choose a bright lipstick colour.

10. Finish with more shading in darker tones.

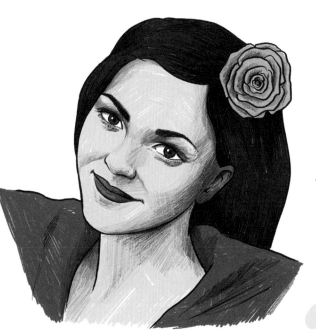

Diamond
Three-quarter view 2

Try varying the three-quarter view by using the diamond guideline at different angles.

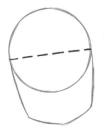

1 Draw a circle. Add a dashed line across the centre, and an angular U-shape below for the jaw.

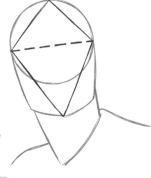

2 Using the dashed line as a guide, draw a diamond that overlaps the circle. Sketch the neck and shoulders below.

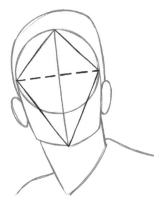

3 Create a rough outline of the hair and ears around the head shape.

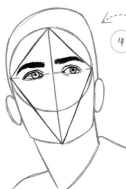

4 Ink the eyes and eyebrows, using the dashed line and diamond as a guide.

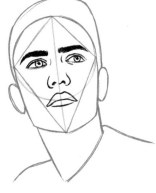

5 Continue with the nose and mouth. Erase your guidelines as you progress.

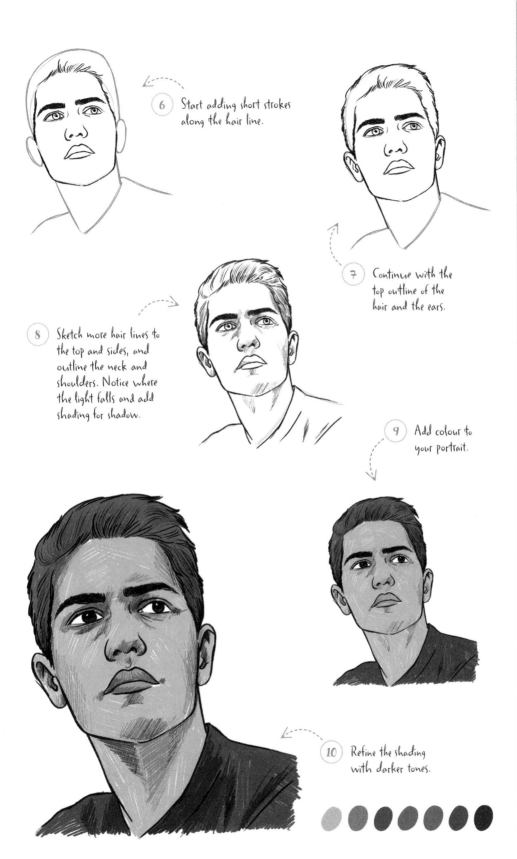

6 Start adding short strokes along the hair line.

7 Continue with the top outline of the hair and the ears.

8 Sketch more hair lines to the top and sides, and outline the neck and shoulders. Notice where the light falls and add shading for shadow.

9 Add colour to your portrait.

10 Refine the shading with darker tones.

Diamond
Front view

For a front view, use the diamond-shaped guide straight on,
but keep a tiny tilt for a more natural look.

1 Draw a circle. Add
a dashed line across
the centre.

2 Using the dashed line as
a guide, draw a diamond
that overlaps the circle, to
help get the proportions of
the face right.

3 Create a rough outline of
the jaw and ears around
the diamond shape.

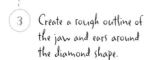

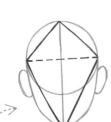

64

4 Sketch the outline
of the bike helmet
and hair.

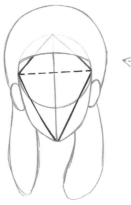

5 Add guides for the shoulders.
Start inking the eyes and
eyebrows, using the dashed
line as a guide.

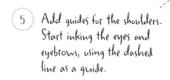

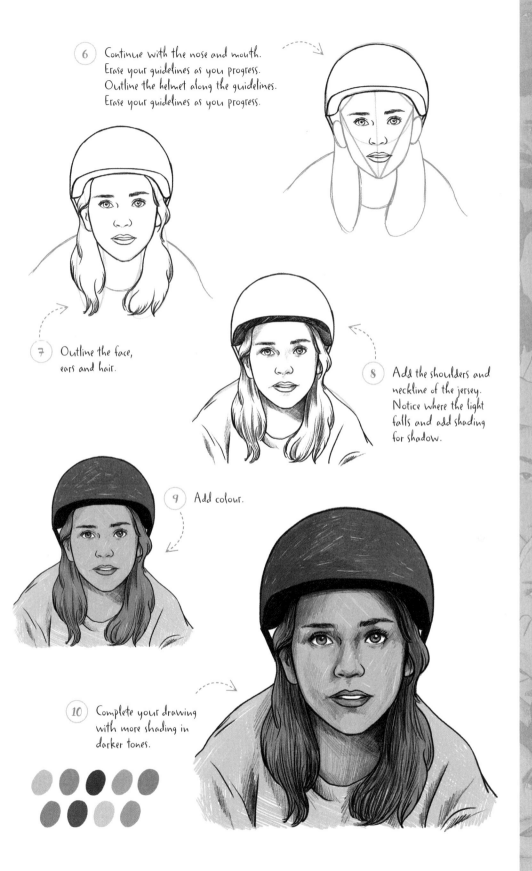

6 Continue with the nose and mouth.
Erase your guidelines as you progress.
Outline the helmet along the guidelines.
Erase your guidelines as you progress.

7 Outline the face,
ears and hair.

8 Add the shoulders and
neckline of the jersey.
Notice where the light
falls and add shading
for shadow.

9 Add colour.

10 Complete your drawing
with more shading in
darker tones.

Heart
Front view 1

Heart-shaped faces have a wider forehead and narrower chins.
Start with this view from the front.

(1) Draw a circle. Add a vertical line through the centre and an arc below for the jaw.

(2) Add a heart shape, to help get the proportions of the face right.

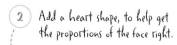

(3) Outline the neck, shoulders and folds of the shirt. Add some diamond shapes to the lower part of the head as a guide for the earrings.

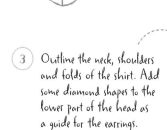

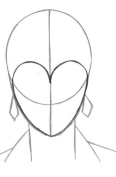

(4) Ink the eyes and eyebrows within the top of the heart shape. Add the nose, where the guidelines form a cross. Erase the guidelines as you progress.

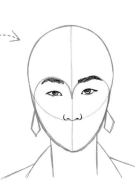

(5) Start to draw the hairline with a series of curved lines.

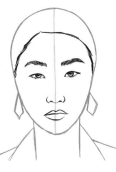

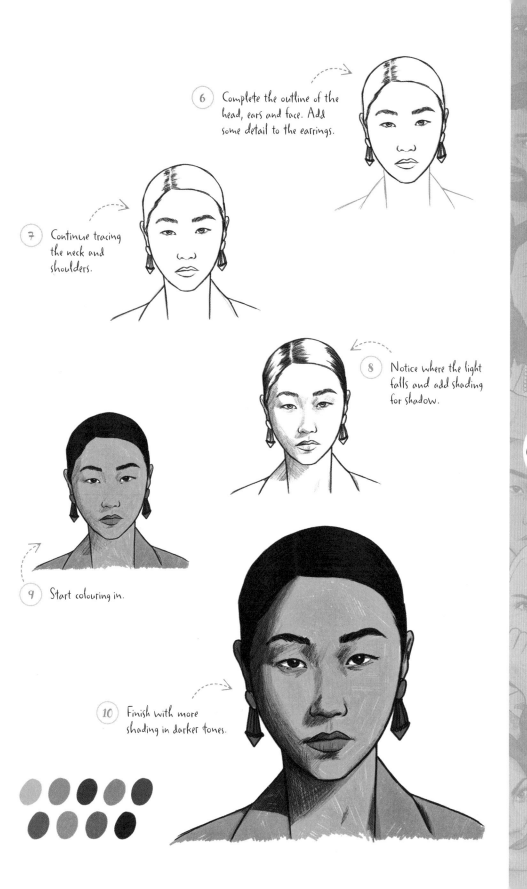

6 Complete the outline of the head, ears and face. Add some detail to the earrings.

7 Continue tracing the neck and shoulders.

8 Notice where the light falls and add shading for shadow.

9 Start colouring in.

10 Finish with more shading in darker tones.

67

Heart
Front view 2

A hand to the cheek gives this heart-shaped
face an element of gravitas.

(1) Draw a circle. Add a vertical
line down the centre, and a
U-shape below for the jawline.

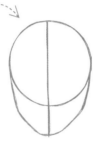

(2) Create a heart shape, as
below, as a guide for the
lower part of the face.

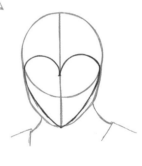

(3) Sketch guidelines
for the hand.

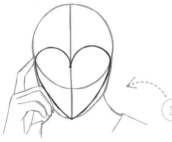

68

(4) Add a rough guide for
the hat. Add the ears.

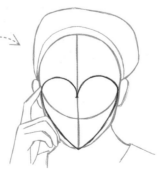

(5) Ink the eyes and eyebrows within
the heart shape. Add the nose
where the guidelines cross.
Draw the mouth below.

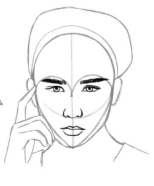

6 Erase the guidelines as you progress. Sketch the outline of the face and ears.

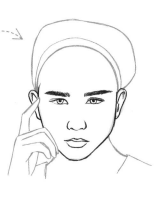

7 Add the hand, hair and hat.

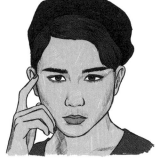

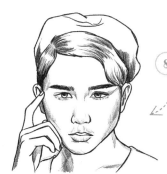

8 Draw the neck and shoulders. Think about where the light falls and add shading for shadow.

9 Add colour, with some bright colours for the eye makeup and nails.

10 Complete your drawing with more shading in darker tones.

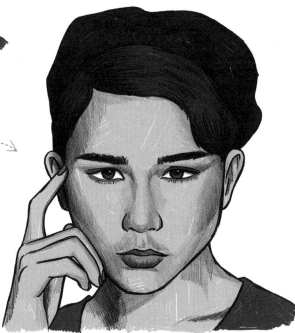

Heart
Three-quarter view

Looking down and away from the light, the areas of the
face that are cast into shadow are more noticeable.

(1) Draw a circle. Add a slightly
curved, vertical line through the
centre. Draw a heart shape below,
as a guide for the lower part of
the face. Note how both shapes
are slightly tilted to show a face
looking down.

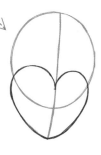

(2) Add guides for the ears,
and a dashed line across
the top of the heart.

(3) Sketch the neck
and shoulders.

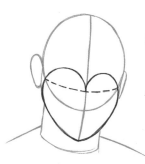

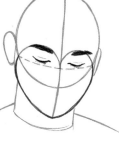

(4) Ink the eyes and eyebrows
within the heart shape,
erasing the guidelines as
you progress.

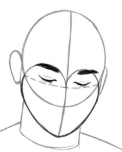

(5) Draw the nose, where
the guidelines form a cross.
Add the mouth below.

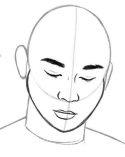

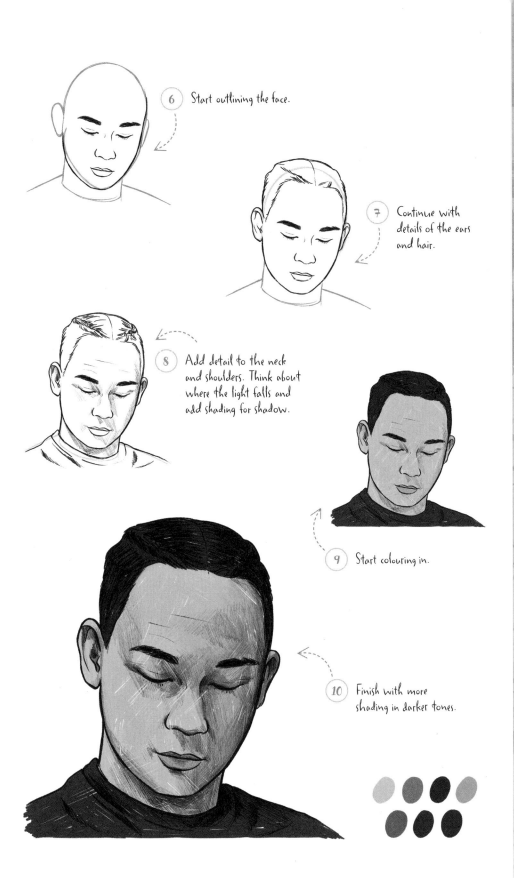

6 Start outlining the face.

7 Continue with details of the ears and hair.

8 Add detail to the neck and shoulders. Think about where the light falls and add shading for shadow.

9 Start colouring in.

10 Finish with more shading in darker tones.

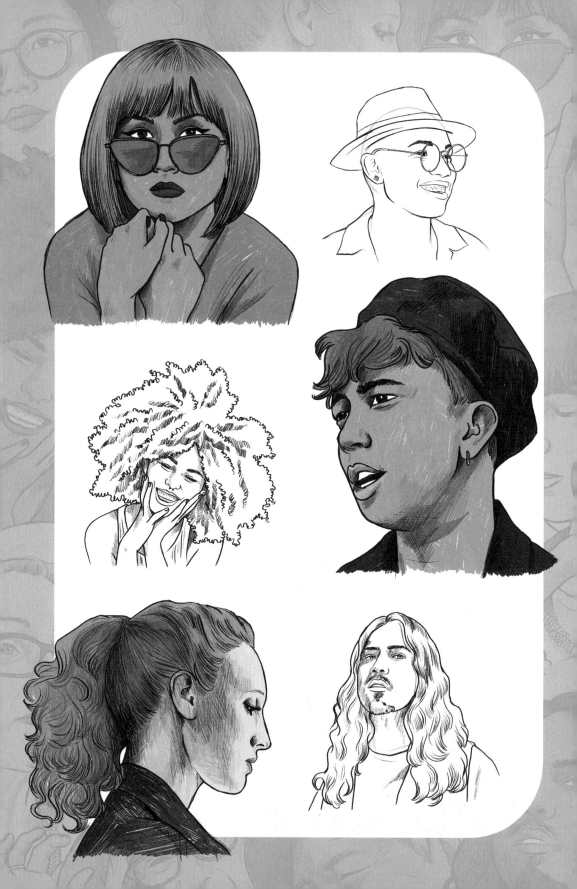

Expressions and Poses

Chin up

The classic chin-up pose is bold, confident and flattering.

1. Draw a squarish shape. Add a horizontal, dashed line through the centre. Trace a vertical line, with a small bend beneath the dashed line. This will be a guide for the nose. Add a small oval below the dashed line for the ear.

2. Sketch guides for the neck and shoulders.

3. Add a pair of glasses on the dashed line, and the outline of a hat.

4. Begin inking with the glasses, as they will overlap the eyes. Then add the nose and mouth on the vertical guideline.

5. Ink the outline of the face, erasing the guidelines as you progress.

Note:
A slightly raised eyebrow or smirk can be very effective to depict feelings.

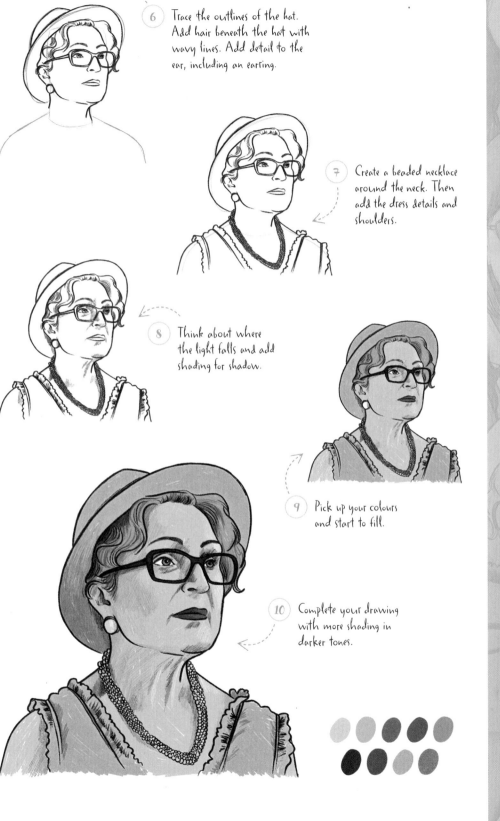

6 Trace the outlines of the hat. Add hair beneath the hat with wavy lines. Add detail to the ear, including an earring.

7 Create a beaded necklace around the neck. Then add the dress details and shoulders.

8 Think about where the light falls and add shading for shadow.

9 Pick up your colours and start to fill.

10 Complete your drawing with more shading in darker tones.

Strike a pose

Self-conscious yet self-possessed, this slightly aloof pose doesn't give anything away.

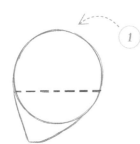

1. Draw a circle for the head. Add a horizontal, dashed line approximately two-thirds down the circle. Add a soft V-shape to the bottom-left for the jawline.

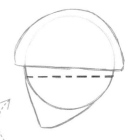

2. Sketch a semicircle over the head as a guide for the hair.

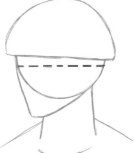

3. Erase the circle guideline inside the hair. Sketch the neck and shoulders.

Note:
Most of the eyebrows will be hidden under the hair, so we won't draw them.

4. Ink the nose, and then the eyes along the dashed line.

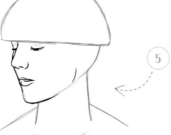

5. Add the mouth and the outline of the face. Erase the guidelines as you progress.

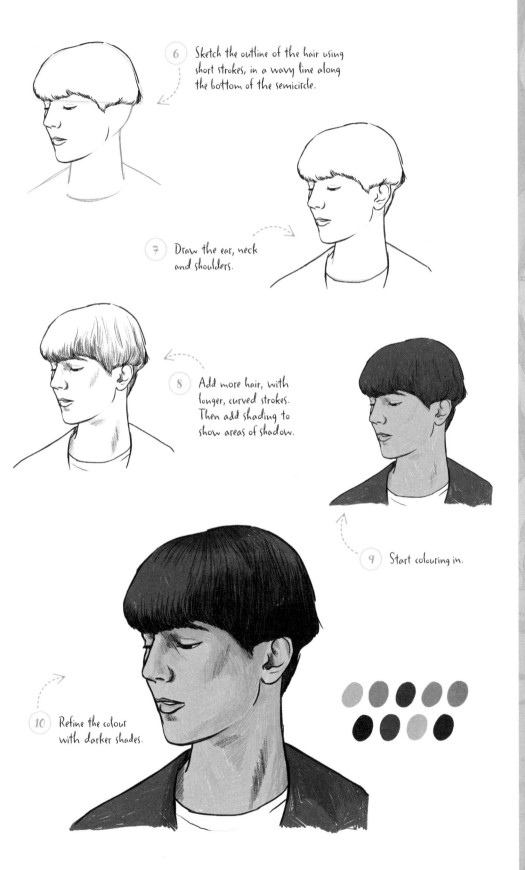

6 Sketch the outline of the hair using short strokes, in a wavy line along the bottom of the semicircle.

7 Draw the ear, neck and shoulders.

8 Add more hair, with longer, curved strokes. Then add shading to show areas of shadow.

9 Start colouring in.

10 Refine the colour with darker shades.

Looking askance

Edgy and a little defensive, this pose oozes cool.

1) Draw a circle for the face. Add a U-shape above for the forehead.

2) Add a slightly curved, dashed guideline from top to bottom. Sketch the eyes, nose and mouth, using the guide.

3) Sketch the outline of the hair, in long, loose waves. Add the neckline and shoulders.

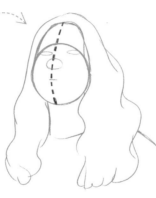

4) Ink the eyes and eyebrows along the top of the circle guide.

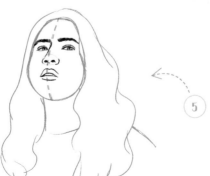

5) Continue with the nose and mouth along the vertical guideline, erasing the guidelines as you progress.

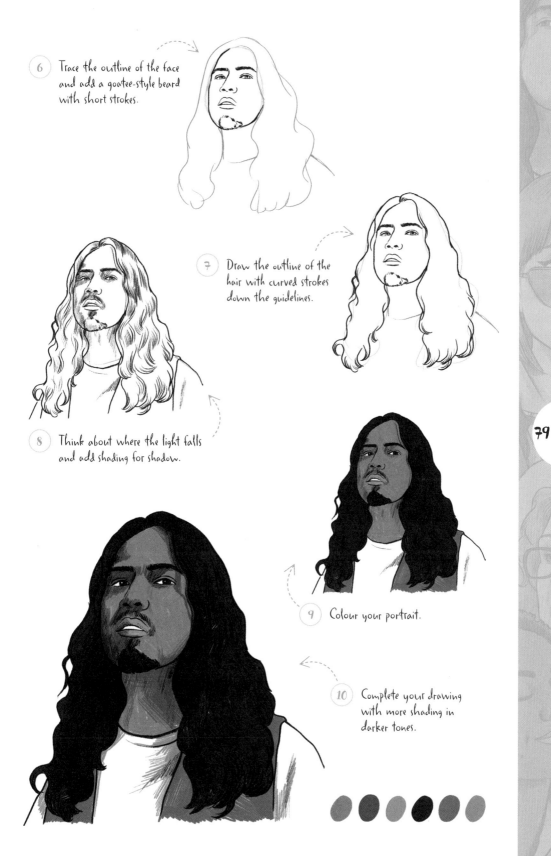

6 Trace the outline of the face and add a goatee-style beard with short strokes.

7 Draw the outline of the hair with curved strokes down the guidelines.

8 Think about where the light falls and add shading for shadow.

9 Colour your portrait.

10 Complete your drawing with more shading in darker tones.

Peace out!

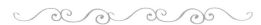

The peace sign, once a symbol for victory, then of peace,
now a suggestion of fun and cuteness.

① Draw a circle for the face. Add a pointed U-shape for the jaw, then add a curved, vertical line through the centre.

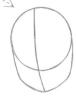

② Add a dashed line across the centre of the circle. Sketch a guide for the hair and neck.

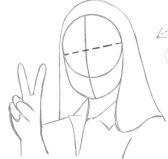

③ Sketch the outline of the hand and shirt.

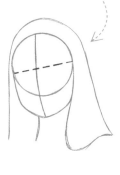

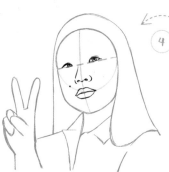

④ Ink the eyes along the dashed line. Continue with the nose and mouth down the vertical guideline. Add a beauty spot to one cheek. Erase the guidelines as you progress.

⑤ Add glasses around the eyes, with eyebrows above them. Trace the outlines of the cap.

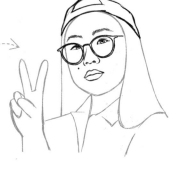

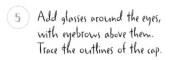

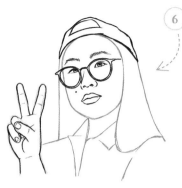

6 Trace the hand over the guidelines.

7 Continue tracing the outline of the hair.

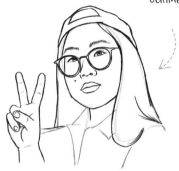

8 Fill in the hair with a series of straight lines. Think about where the light falls and leave those areas light. Add shading for shadow.

9 Start colouring in.

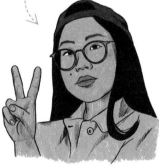

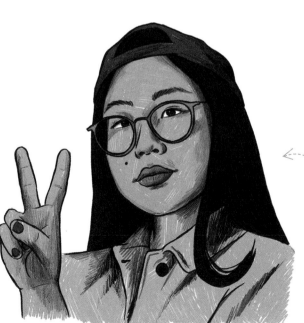

10 Finish with more shading in darker tones.

Wisdom

Older features can be intricate to draw,
with fine lines deep-set in weathered skin.

1 Draw a circle for the face. Add two dashed, horizontal lines across the centre.

2 Create a shape for the jaw below the circle. Add an oval for the ear, within the circle to the right.

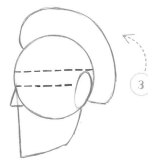

3 Sketch the shape of the hair on top of the head. Add a triangle for the nose.

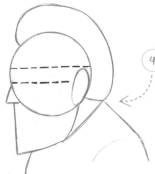

4 Finish your pencil guide by adding the neck and shoulders.

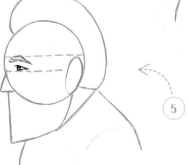

5 Ink the eye and eyebrow between the dashed lines, erasing the guidelines as you progress.

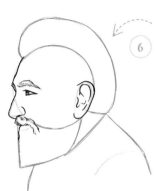

6) Trace the outline of the face and the ear. Draw the moustache, with a series of short strokes.

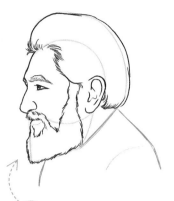

7) Draw the outlines of the hair and beard.

8) Add detail to the hair, beard and clothing. Look carefully at the skin and draw some fine, curved lines to indicate age. Add some shading for shadow.

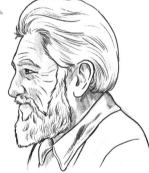

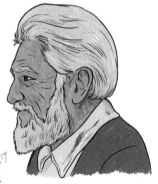

9) Add colour to the skin, eyes, hair and clothing.

10) Complete your drawing with more shading in darker tones.

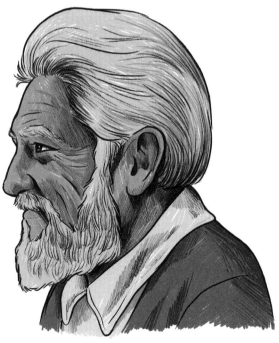

Downcast

The high ponytail contrasts with the downcast expression here,
made more sombre with the use of dark tones on the cheek.

1 Draw a circle for the face. Divide it with a dashed, diagonal line.

2 Add two triangles to the bottom left of the circle. The lower one is for the jaw, the upper one for the nose.

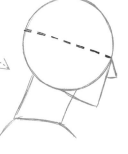

3 Sketch the neck and shoulders.

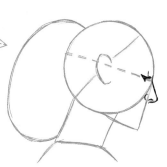

4 Create a guide for the ponytail.

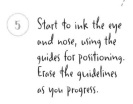

5 Start to ink the eye and nose, using the guides for positioning. Erase the guidelines as you progress.

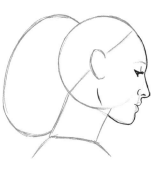

6 Continue inking the outline of the face.

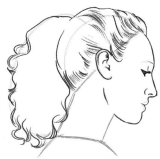

7 Draw the ear. Add the hair using a mixture of wavy and curly strokes.

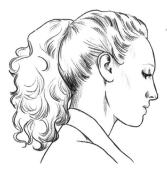

8 Add more curls to the ponytail. Think about where the light falls and add shading for shadow.

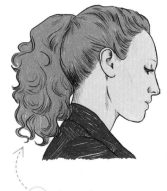

9 Start colouring in.

10 Finish with more shading in darker tones.

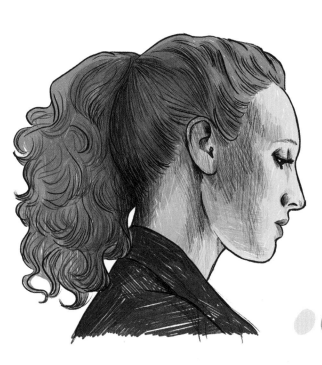

Contemplative

Head on hand with averted eyes is a captivating pose,
suggesting a moment of contemplation.

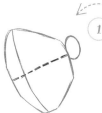

1. Sketch a rough outline for the face, as shown. Add vertical and horizontal guidelines through the centre. Add an oval on the right for the ear.

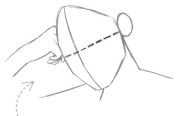

2. Continue with guides for the neck and shoulders. Add a hand for the head to lean on.

3. Add the outline of the hair, with two long, thin outlines for the plaits.

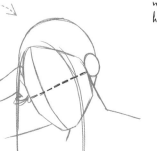

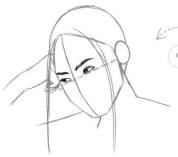

4. Start to ink the eyes and eyebrows along the dashed line, erasing the guidelines as you progress.

5. Continue with the nose and mouth.

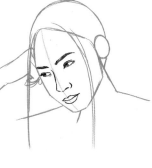

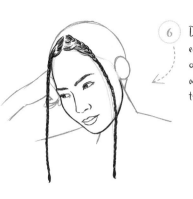

6 Draw the two long plaits down each side of the face, using pairs of curved strokes that get smaller and smaller. Ink the outline of the face.

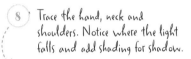

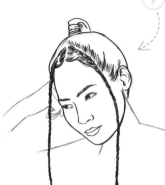

7 Continue adding the hair. Trace the outline of the top of the head, and a ponytail coming out of a thick hairband. Add the ear.

8 Trace the hand, neck and shoulders. Notice where the light falls and add shading for shadow.

9 Choose colours for the skin, hair and makeup.

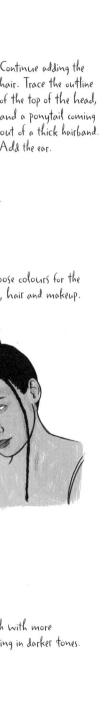

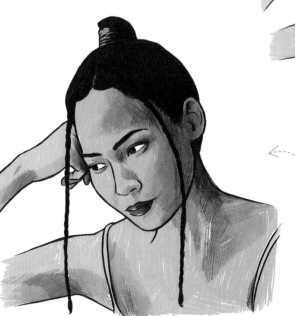

10 Finish with more shading in darker tones.

Joyful

In this joyful expression, the laugh affects the
whole of the face, not just the mouth.

(1) Draw a circle for the face.
Add a diagonal, dashed
line across the centre.

(2) Sketch a rough
shape of hands.

(3) Add guides for
the shoulders.

(4) Create a curly
outline of the hair.

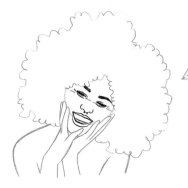

(5) Start to ink the smiling eyes,
eyebrows, nose with piercing,
and a laughing mouth. Use the
guidelines for positioning. Erase
the guidelines as you progress.

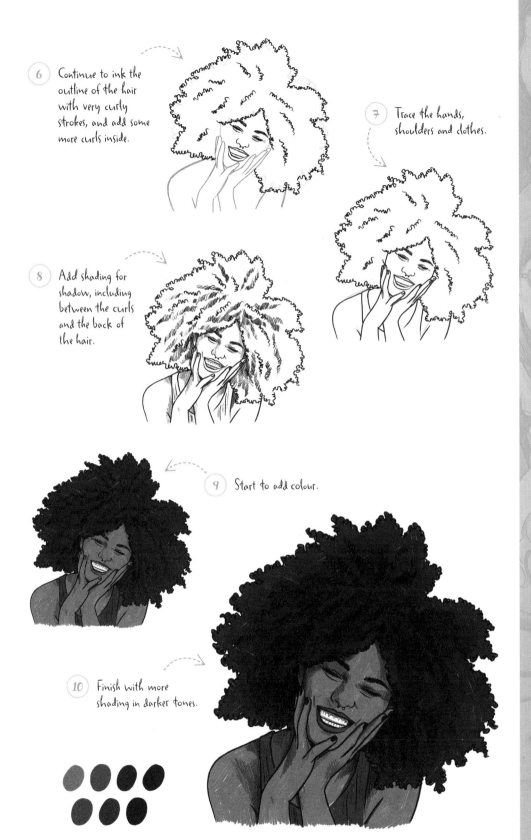

6 Continue to ink the outline of the hair with very curly strokes, and add some more curls inside.

7 Trace the hands, shoulders and clothes.

8 Add shading for shadow, including between the curls and the back of the hair.

9 Start to add colour.

10 Finish with more shading in darker tones.

The singer

With this defiant pose, where the head is turned away,
getting the perspective right will be key.

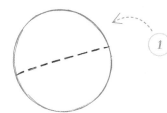

1 Draw a circle for the face. Add an angled, dashed line across the centre.

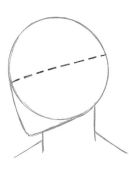

2 Sketch a V-shape below-left for the jaw. Outline the neck and shoulders.

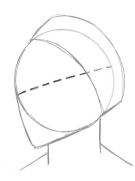

3 Draw the outline of the hat over the circle guide.

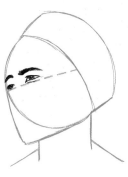

4 Start to ink the eyes and eyebrows along the dashed line, erasing the guidelines as you progress.

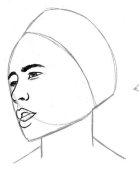

5 Continue with the nose and mouth. Think about perspective.

6 Trace the outline of the face. Add some hair on the forehead using loose, curved strokes.

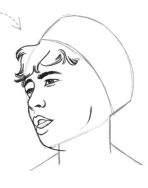

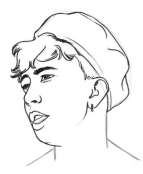

7 Add the edge of more hair down the side and draw the ear with an earring. Add the hat.

8 Think about where the light falls and add shading for shadow.

9 Add colour, with the hair colour of your choice.

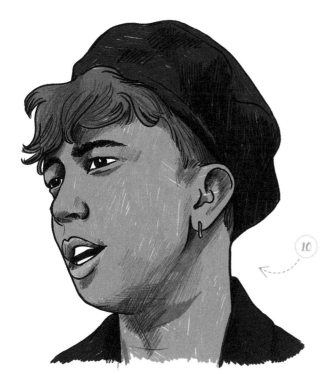

10 Complete your drawing with more shading in darker tones.

Statement hair

An interesting pose, the cool and confidence of the straight-on stare is balanced by the self-conscious hands to chin.

① Draw a circle for the face and a four-sided shape below for the jaw.

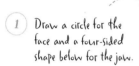

② Add a vertical line through the centre and a horizontal, dashed line across the lower part of the circle.

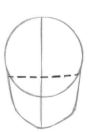

③ Sketch the outline of the hands, overlapping the chin guide slightly.

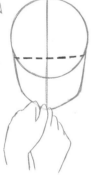

④ Create shapes for the hair, with shoulders on each side.

⑤ Begin to ink the glasses, using the dashed line for positioning. Erase the guidelines as you progress.

6 Continue with the eyes, eyebrows, nose and mouth.

7 Trace the outline of the hair all around the face. Continue with the hands.

8 Add more hair with a series of long strokes. Outline the shoulders and creases in the clothing. Notice where the light falls and add shading for shadow.

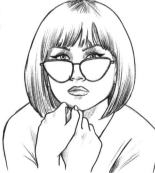

9 Choose and apply colour to the skin, eyes, lips, hair and sunglasses.

10 Finish with colour to the nails. Refine the shading with darker shades.

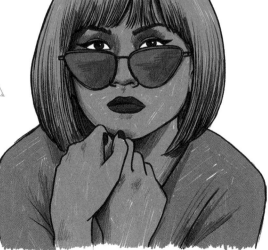

The chuckle

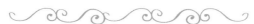

The contrast of grey hair, closed eyes and creased, weathered skin makes an interesting portrait.

1. Sketch the rough shape of the head. As this one is quite angular, use a series of straight lines to form an octagon.

2. Draw two horizontal, dashed lines, spaced at intervals of one-third.

3. Add guides for the ear, neck and shoulders.

4. Continue with guides for the hair and hat.

5. Start to ink the eyebrows, eyes, mouth and moustache, using the dashed lines as guides.

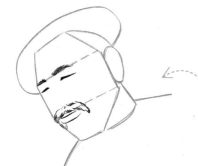

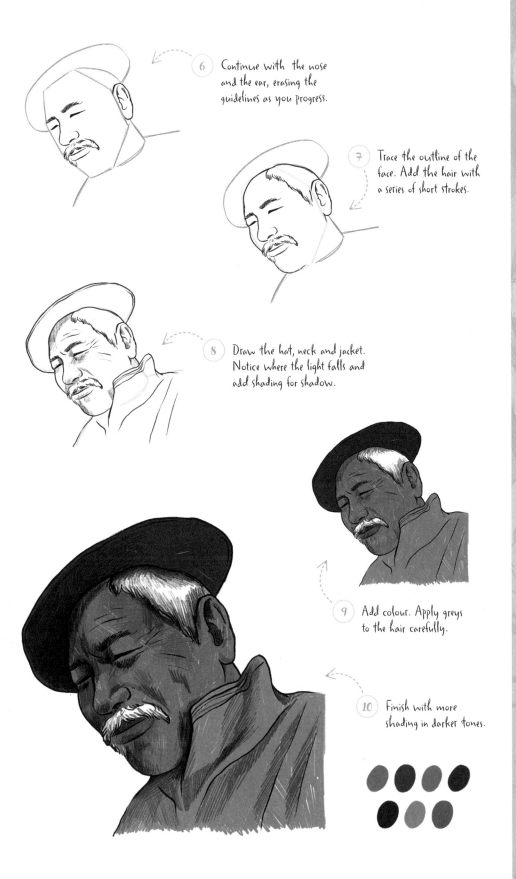

6 Continue with the nose and the ear, erasing the guidelines as you progress.

7 Trace the outline of the face. Add the hair with a series of short strokes.

8 Draw the hat, neck and jacket. Notice where the light falls and add shading for shadow.

9 Add colour. Apply greys to the hair carefully.

10 Finish with more shading in darker tones.

Collar up

In this pose, the hands on the collar visually support
the chin, making an interesting composition.

1. Draw a circle for the face.

2. Sketch an oblong to the lower right side for the jaw. Draw a vertical line in the centre.

3. Add a V-shape from the middle of the circle to the bottom of the oblong.

4. Draw three dashed lines, to help place the facial features.

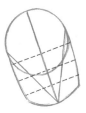

5. Start to ink the eyes, eyebrows, nose and mouth along the guidelines.

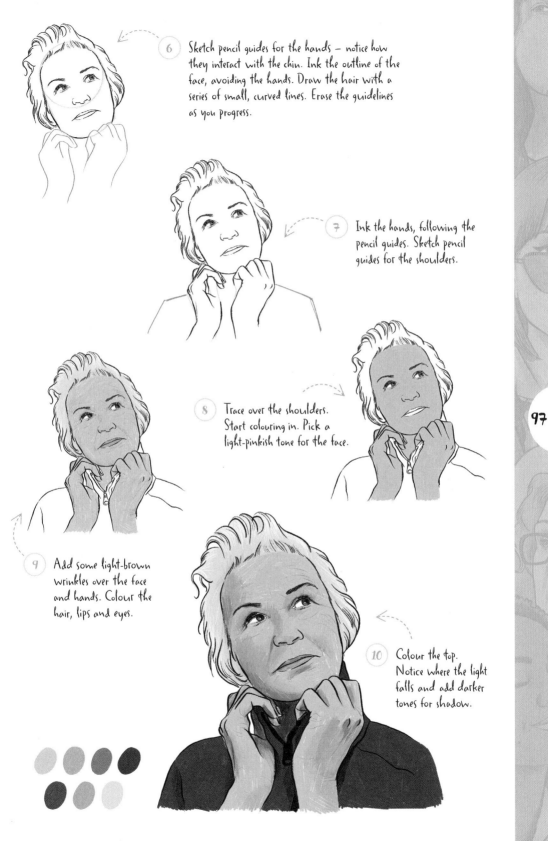

6 Sketch pencil guides for the hands – notice how they interact with the chin. Ink the outline of the face, avoiding the hands. Draw the hair with a series of small, curved lines. Erase the guidelines as you progress.

7 Ink the hands, following the pencil guides. Sketch pencil guides for the shoulders.

8 Trace over the shoulders. Start colouring in. Pick a light-pinkish tone for the face.

9 Add some light-brown wrinkles over the face and hands. Colour the hair, lips and eyes.

10 Colour the top. Notice where the light falls and add darker tones for shadow.

Looking back

Here, hooped earrings tie in with a circular bun, while looking
back over one shoulder suggests mystery and intrigue.

1. Draw a circle for the head. Add a
 horizontal, dashed line across the
 lower part of the circle. Add two
 almond shapes to the right. These will
 become the eyes. Add a diagonal line
 across the circle, as a guide for the hair.

2. Add a tiny tube
 shape for the nose,
 and under it a round
 V-shape for the jaw.

3. Sketch an oval shape at
 the top of the head for
 the bun. Outline the
 neck and shoulders.

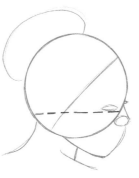

4. Start to ink the eyes
 and eyebrows. Only the
 eyelashes and hint of an
 eyebrow should be visible
 for the far eye.

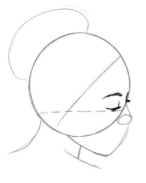

5. Add the ear, nose and
 mouth, erasing the
 guidelines as you progress.

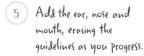

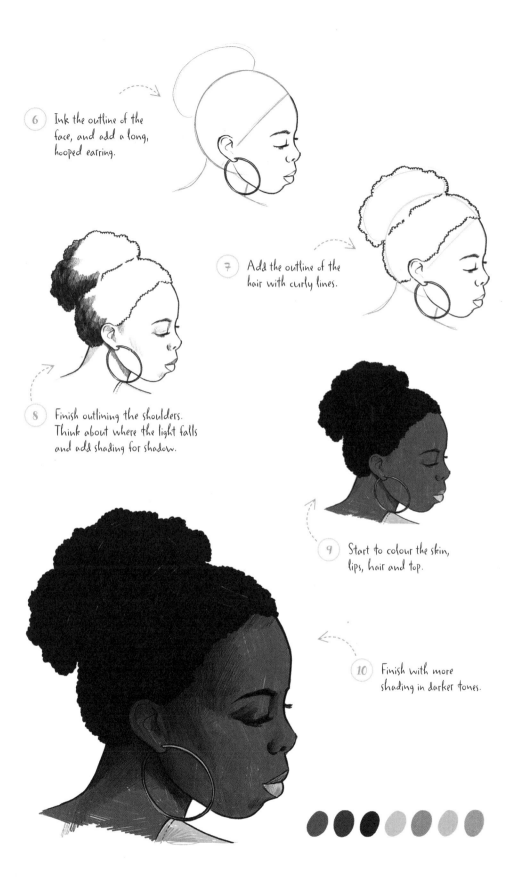

6 Ink the outline of the face, and add a long, hooped earring.

7 Add the outline of the hair with curly lines.

8 Finish outlining the shoulders. Think about where the light falls and add shading for shadow.

9 Start to colour the skin, lips, hair and top.

10 Finish with more shading in darker tones.

Angular style

Carefully chosen accessories can add impact to portraits.
The angular hat and jawline compliment each other here.

1 Draw an angular shape for the face and add three horizontal, dashed lines, as shown.

2 Add two long shapes on each side as guides for the hair, and another horizontal line for the fringe.

3 Sketch a shape for the hat, and outline the neck and shoulders.

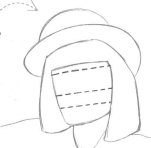

4 Start to ink the eyes, nose and mouth along the dashed line. The eyebrows will be hidden under the fringe. Erase the guidelines as you progress.

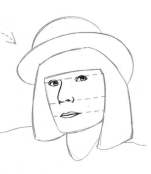

5 Continue to ink the glasses, and trace the outline of the face. Add a few soft lines around the eyes and mouth to create wrinkles.

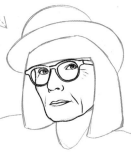

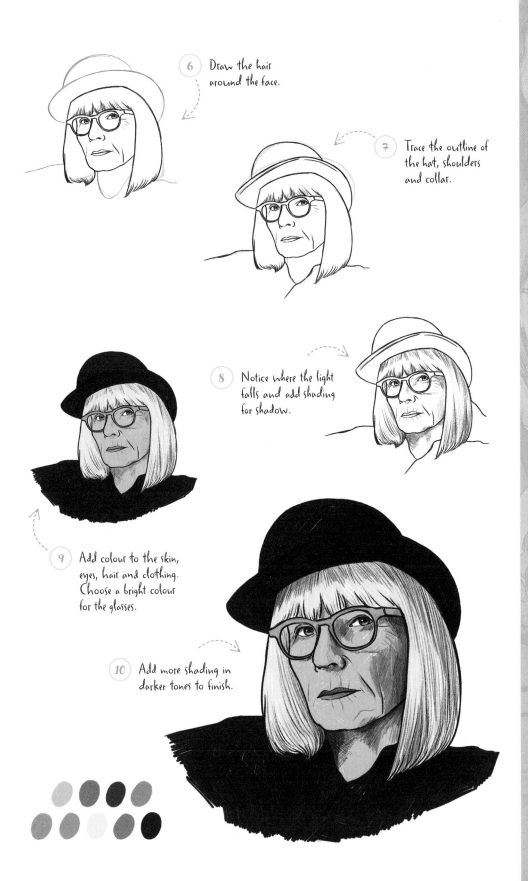

6 Draw the hair around the face.

7 Trace the outline of the hat, shoulders and collar.

8 Notice where the light falls and add shading for shadow.

9 Add colour to the skin, eyes, hair and clothing. Choose a bright colour for the glasses.

10 Add more shading in darker tones to finish.

101

Power of music

A portrait of bliss – even closed eyes can convey joy with an upturned chin and slightly smiling mouth.

1. Draw a circle for the face. Add a horizontal, dashed line through the centre.

2. Add a V-shape for the jaw and two lines for the neck.

3. Sketch the outline of the hair in three large hoops. Add an oval for the ear cup of the headphones.

4. Start to ink the eyes and eyebrows along the dashed line.

5. Continue with the nose and mouth, erasing the guidelines as you progress. If you like, add a piercing to the nose.

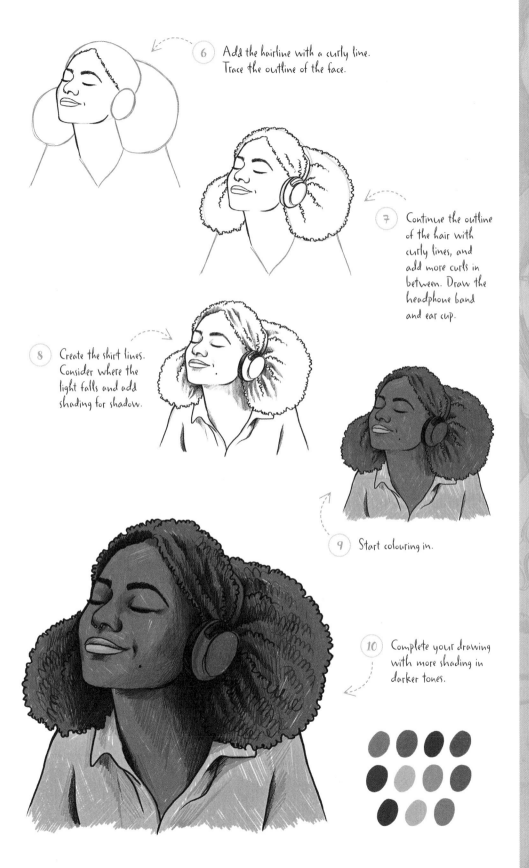

6 Add the hairline with a curly line. Trace the outline of the face.

7 Continue the outline of the hair with curly lines, and add more curls in between. Draw the headphone band and ear cup.

8 Create the shirt lines. Consider where the light falls and add shading for shadow.

9 Start colouring in.

10 Complete your drawing with more shading in darker tones.

Thinking

There are no frills with this portrait – it's honest and raw –
getting the skin tone right is key.

1. Draw an oval for the face. Add two dashed, horizontal lines across the lower half.

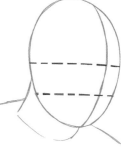

2. Add a second curve inside the right of the oval, to make a guide for the centre of the face. Outline the neck and shoulders.

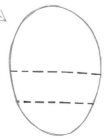

3. Sketch a V-shape for the nose and a small oval for the ear.

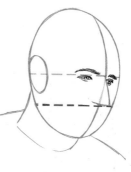

4. Start to ink the eyes and eyebrows along the upper dashed line. Erase the guidelines as you progress.

5. Continue with the nose and mouth.

6 Trace the outline of the head, and add detail to the ear. Try and keep the outline of the head as smooth as possible.

7 Continue with the neck and shoulders.

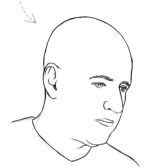

8 Notice where the light falls and add shading for shadow.

9 Start colouring in, adding a lighter tone where the light hits the face and neck.

10 Refine the shading with darker tones.

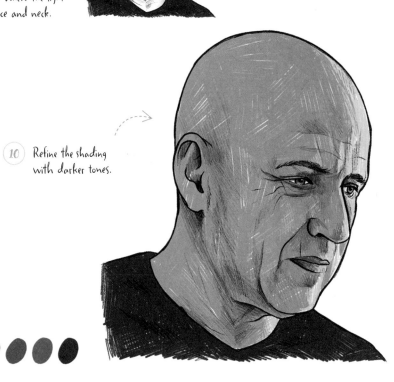

The smile

The chic sophistication of a fedora hat worn with round glasses is a look of strength and confidence.

① Draw a circle for the face.

② Sketch a triangular shape to the lower right of the circle for the jaw and chin. Add two vertical lines for the neck.

③ Add a curved, vertical line inside the right edge, as a guide for the centre of the face. Draw three horizontal, dashed lines across the lower part of the face shape. Outline the shoulders.

④ Start to ink the glasses. Then add the eyes and nose. Watch how these interact with the dashed lines.

⑤ Continue with the eyebrows, ear and the mouth, erasing the guidelines as you progress.

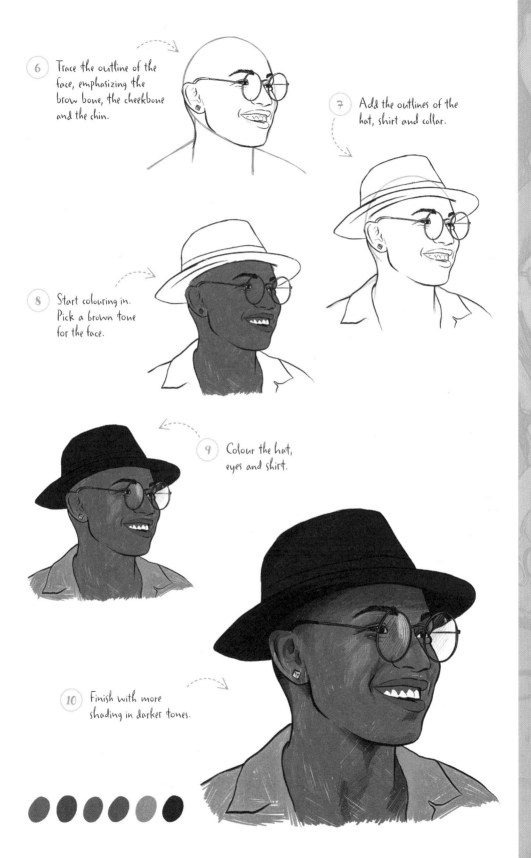

6. Trace the outline of the face, emphasizing the brow bone, the cheekbone and the chin.

7. Add the outlines of the hat, shirt and collar.

8. Start colouring in. Pick a brown tone for the face.

9. Colour the hat, eyes and shirt.

10. Finish with more shading in darker tones.

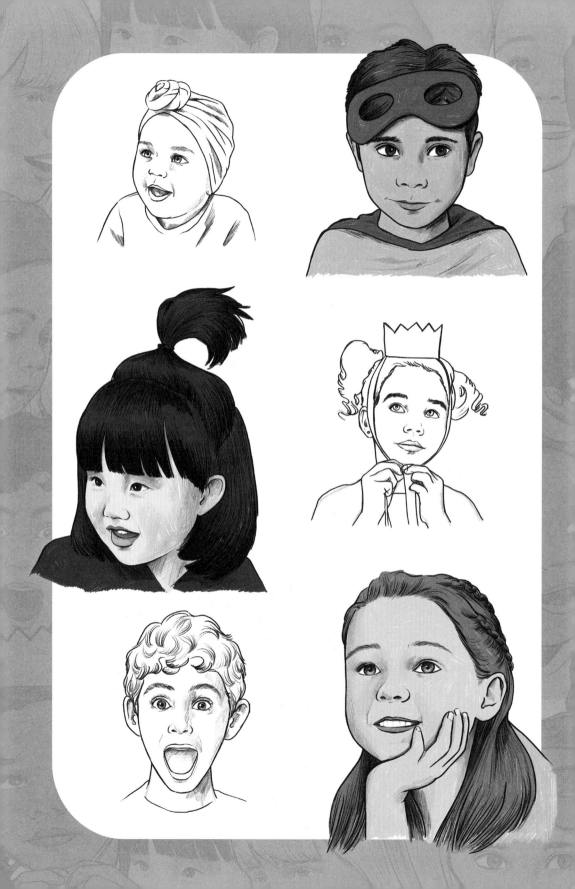

Children

Ready to play

A mop of blonde hair in a simple style makes this fresh-faced
youngster a perfect starting point for drawing children.

1 Draw a circle for the face. Add
 a V-shape below-right for the
 jaw. Then erase the part of the
 circle between the V-shape.

2 Add a curved, vertical line inside
 the right edge, as a guide for the
 centre of the face. Add two
 horizontal, dashed lines across
 the lower half.

3 Sketch the neck and
 shoulders. You now have
 the general pose of the child.

4 Start to ink the child's
 hair, as it will cover a lot
 of the face. Erase the
 guidelines as you progress.

5 Continue with the eyes,
 nose and mouth, using the
 guidelines for positioning.

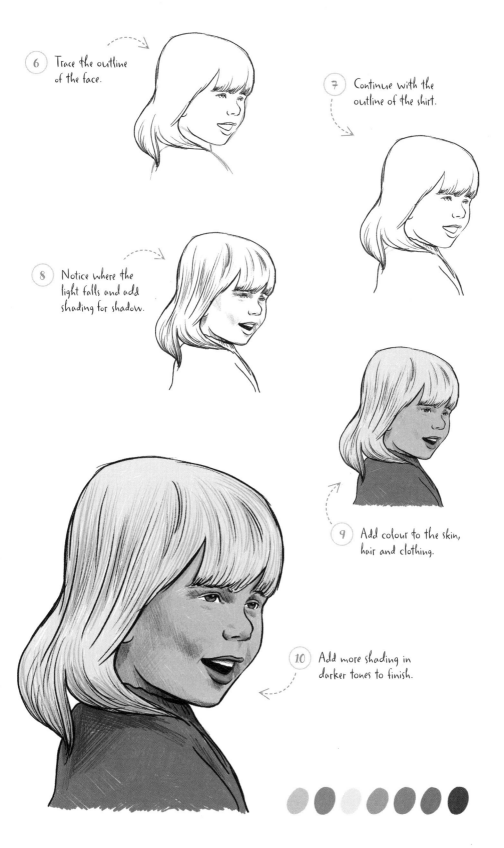

6 Trace the outline of the face.

7 Continue with the outline of the shirt.

8 Notice where the light falls and add shading for shadow.

9 Add colour to the skin, hair and clothing.

10 Add more shading in darker tones to finish.

Eager to learn

Children's faces are more round than adults', and their eyes usually shine more brightly – this portrait is no exception!

1 Draw a circular shape for the head. Add an oval on the side for the ear. Sketch an arc over the top for the hair.

2 Add a horizontal, dashed line through the centre. Sketch the hand, which will overlap the chin.

3 Use a curved, vertical line through the centre of the circle to help position the facial features. Across this line add the nose and a small line for the mouth.

4 Start to ink the big eyes along the dashed line, with eyebrows above, erasing the guidelines as you progress.

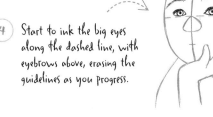

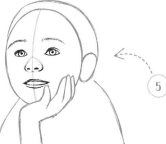

5 Continue with the nose and mouth.

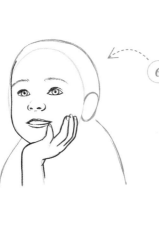

6 Trace the outline of the face and hand.

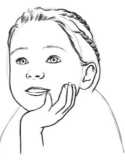

7 Draw the hair around the forehead with curved strokes. Add two plaits to the top.

8 Add more hair, with long, curved strokes at the bottom. Notice where the light falls and add shading for shadow.

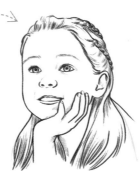

9 Start colouring in.

10 Refine the shading with darker tones.

Party crown

Apprehension at the start of a birthday party
makes an interesting expression and pose.

(1) Draw an oval
for the head.

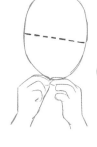

(2) Add a horizontal, dashed
line across the centre.
Sketch guidelines for the
hands, just overlapping
the chin.

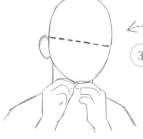

(3) Sketch a small oval for the
ear. Add guides for the neck
and shoulders.

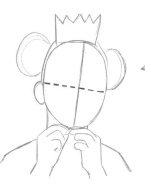

(4) Add a vertical line for the centre
of the face. Create two arcs on
each side of the head for the
bunches, and the outline of a
crown on top.

(5) Start to ink the eyes, eyebrows,
nose and mouth, using the
guidelines for positioning. Erase
the guidelines as you progress.

6 Continue with the outline of the paper crown and its ribbon around the face.

7 Draw curly bunches on each side of the head. Add the ear, with a small stud earring.

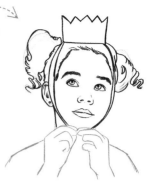

8 Trace the hands and shoulders. Add shading for shadow.

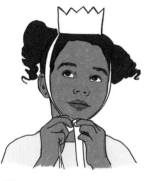

9 Add colour to the skin, eyes and hair. Choose a background colour for the clothing.

10 Finish with colour to the crown, a dotty pattern to the top and darker tones for shadow.

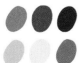

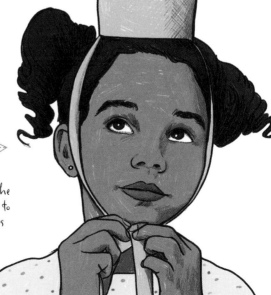

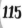

Woolly hat

A pair of dungarees and a woolly hat add
a capital 'C' to cute in this portrait.

① Draw a circle for the head.
Add a horizontal, dashed
line across the lower half.

② Add a V-shape below-right
for the jaw. Sketch the neck
lines below.

③ Create some pencil details
to the shoulders and
clothing. Draw a small
oval for the ear.

④ Sketch the shape of a
hat over the circle.

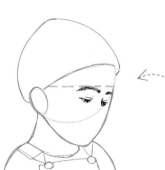

⑤ Start to ink the eyes and
eyebrows under the dashed
line, erasing your guidelines
as you progress.

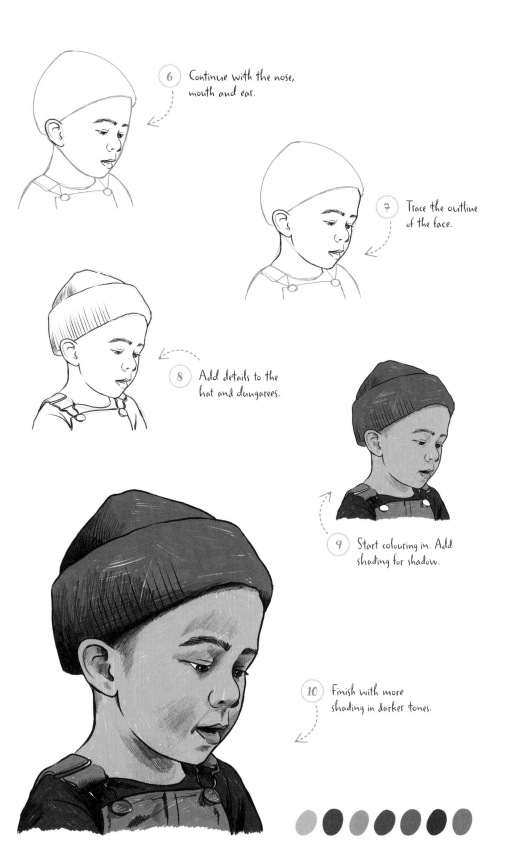

6 Continue with the nose, mouth and ear.

7 Trace the outline of the face.

8 Add details to the hat and dungarees.

9 Start colouring in. Add shading for shadow.

10 Finish with more shading in darker tones.

Baby laugh

A colourful headwrap accentuates the joy in this baby's laugh.

1. Draw a circle for the head. Add a horizontal, dashed line across the lower half.

2. Add a U-shape to the bottom left for the jaw.

3. Sketch an arc diagonally down the circle for the front of the headwrap.

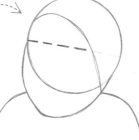

4. Start to ink the eyes and eyebrows under the dashed guideline.

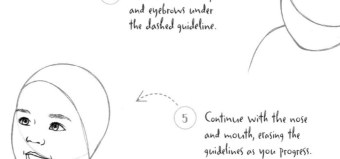

5. Continue with the nose and mouth, erasing the guidelines as you progress.

6 Trace the outline of the headwrap.

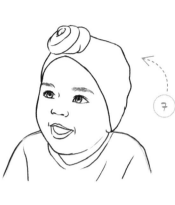

7 Continue with the folds of the clothing.

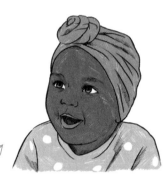

8 Add some shading for shadow.

9 Colour the skin, eyes, headwrap and clothing.

10 Refine the shading with darker tones.

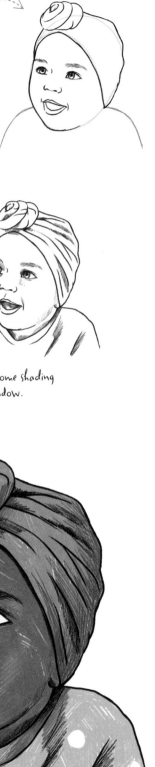

119

Surprise!

A birthday party? A present? Whatever it is, it's
beyond this boy's wildest dreams!

1 Draw a circle for the face.
Add a U-shape below for
the jaw.

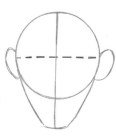

2 Add a vertical and a
horizontal, dashed line
through the centre. Add two
ovals on the sides for the ears.

3 Sketch a long arc
above the head as
a guide for the hair.

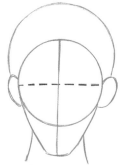

4 Start to ink the big,
surprised eyes above the
dashed line. Erase the
guidelines as you progress.

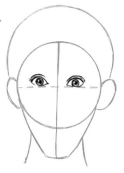

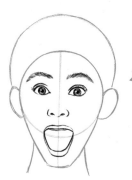

5 Continue with the
eyebrows, nose and
open mouth.

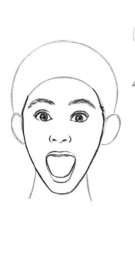

6 Trace the outline of the face.

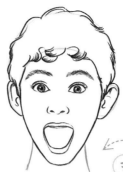

7 Add the outline of the curly hair. Draw both ears.

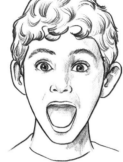

8 Draw the neck and shoulder lines. Add shading for shadow.

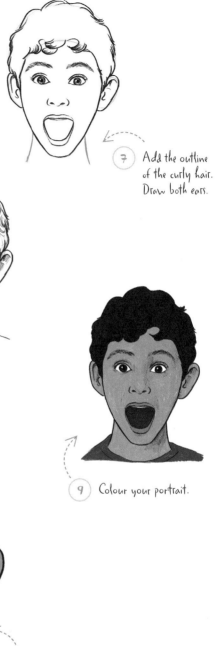

9 Colour your portrait.

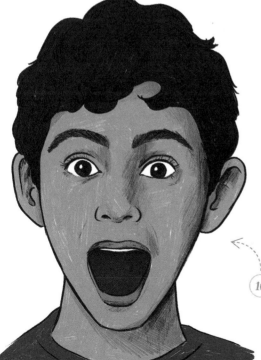

10 Add more shading in darker tones to finish.

Baby bonnet

A picture of innocence and plump-cheeked
cuteness in a soft-grey bonnet.

1. Draw a squareish shape for the face.
Add a vertical line to the left, as a
guide for the middle of the baby's
face. Add a horizontal, dashed line
across the centre.

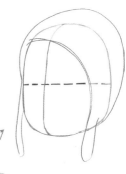

2. Sketch the bonnet
on top of the head.

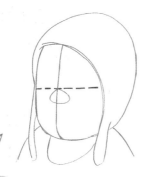

3. Add a nose shape at the
junction of the guidelines.
Draw lines for the shoulders
and scooped neckline.

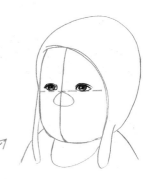

4. Start to ink the eyes
above the dashed line.
Erase the guidelines as
you progress.

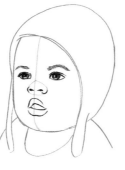

5. Continue with
the eyebrows, nose
and open mouth.

6 Trace the outline of the face.

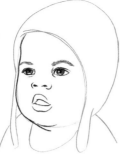

7 Continue with the outline of the bonnet.

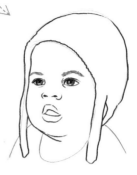

8 Ink the shoulders and neckline. Add some shading for shadow.

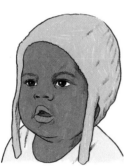

9 Start colouring in.

10 Finish with more shading in darker tones.

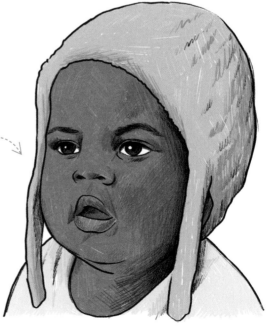

Curiosity

Try this inquisitive child's expression, emphasized by a straight fringe and jaunty ponytail.

1. Draw an oval guide for the face. Add a curve for the back of the head.

2. Add a curve from the top of the head to the middle of the face, to divide the face and help position the nose. Add two dashed, horizontal lines as guides for the eyes and mouth.

3. Sketch the basic outline of the hair. Then erase the guidelines that are inside the hair shape. Add guidelines for the shoulders.

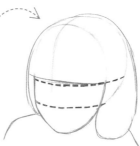

4. Start to ink the eyes, nose and mouth, using the dashed lines to position them. Erase the guidelines as you progress.

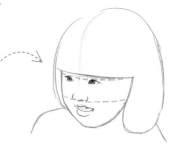

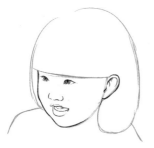

5. Continue with the outline of the face along the guidelines, but give it more shape. Define the cheekbones, chin and jawline. Add the ear at the top of the jawline.

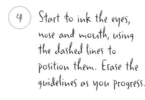

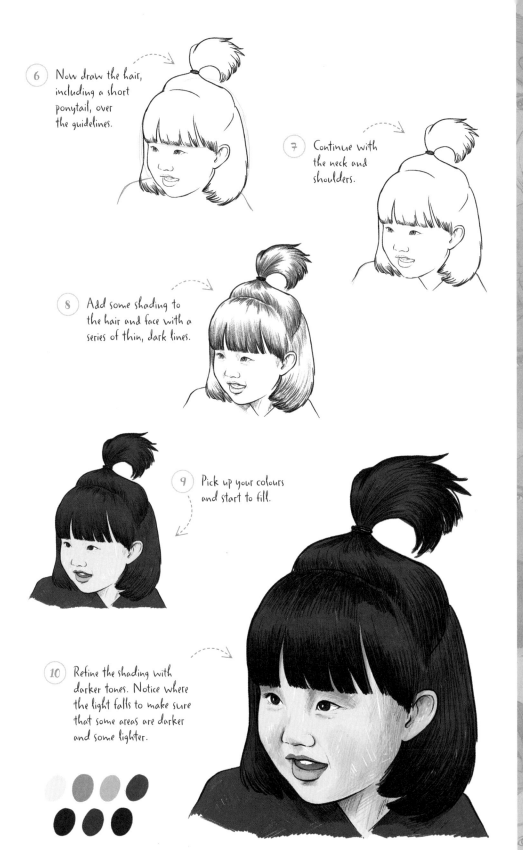

6 Now draw the hair, including a short ponytail, over the guidelines.

7 Continue with the neck and shoulders.

8 Add some shading to the hair and face with a series of thin, dark lines.

9 Pick up your colours and start to fill.

10 Refine the shading with darker tones. Notice where the light falls to make sure that some areas are darker and some lighter.

Superhero

A cheeky, mischievous glance suggests this
superhero is about to have a lot of fun!

1) Draw a circle for the face. Add
a curved, vertical line through
the centre, and connect the
bottom of the line to the edges
of the circle for the jaw.

2) Add a dashed line across the
lower half of the circle and
ear shapes to both sides.
Sketch guides for the neck
and shoulders below.

3) Sketch a superhero
mask over the top
of the head shape.

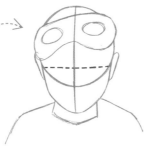

4) Start to ink the eyes
and eyebrows above the
dashed line, erasing the
guidelines as you progress.

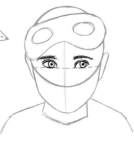

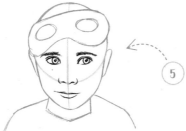

5) Continue with the nose and
mouth, using the guidelines
for positioning.

6 Trace the outline of the face and superhero mask.

7 Add the hair with a series of short strokes. Ink detail to the ears.

8 Draw more hair, including inside the holes of the mask. Add the shoulders, shirt and top of the cape. Add shading for shadow.

9 Start colouring in, using bright, superhero colours.

10 Finish with more shading in darker tones.

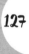

About the Artist

Justine Lecouffe is an illustrator, designer and storyboard artist based in the UK. Her work focuses on digital illustration, graphic design and some dabbling in motion media. Themes of femininity, beauty and nature often dominate her work, making it the perfect fit for clients in the fashion, jewellery and cosmetic sectors. She specializes in design and illustration, but has a long and ambitious wish list of styles and genres to master. When she's not drawing, you can find her cooking comfort food, cycling, snapping film photos, or simply scrolling dog and cat memes.

If you'd like to find out more information or see further examples of her work, find Justine on Instagram @justine_lcf.

Acknowledgements

Many thanks to all the readers of the previous titles in the *10-Step Drawing* series: *People, Everyday Things, Cats,* and *Dogs,* who gave me such positive feedback. This was wonderful encouragement and pushed me to draw for this fifth publication. I love seeing your drawings, so feel free to continue sending them through my Instagram.

I'm again immensely grateful to the team at The Bright Press for another fantastic opportunity and their brilliant support throughout the project.

I would like to thank the following for the use of their images, which I used as references to recreate the projects in this book: **Pexels** 40 Pixabay; 42 Pravin Maniam; 46 Cottonbro Studio; 48 Rodnae Productions; 50 Slaytina; 52 Roman Odintsov; 54 Saranjeet Singh; 56 Rüveyda; 58 Javon Swaby; 60 Natalia Malushina; 62 Rüveyda; 64 Tehmasip Khan; 66 Brett Sayles; 68 Cottonbro Studio; 70 Vincent Tan; 74 Andrea Piacquadio; 76 Anna Shvets; 78 Arianna Jadã; 80, 82, 84, 86 Cottonbro Studio; 88 Guilherme Ameida; 90 Ike Louie Natividad; 92 Mabel Lee; 94 Mehmet Turgut Kirkgoz; 96, 98 Moe Magners; 100 Rfstudio; 102 Jorge Fakhouri Filho; 104 Thomas Ronveaux; 106 Wilson Vitorino; 110 Allan Mas; 112, 114 Cottonbro Studio; 116 Ketut Subiyanto; 118 William Fortunato; 120 Mohamed Abdelghaffar; 122 Mwabonje; 124; Pixabay; 126 Tehmasip Khan; **Unsplash** 44 Janko Ferlic.